IMAGES
of America

RANCHOS OF
SAN DIEGO COUNTY

PARKS AND RECREATION
COUNTY OF SAN DIEGO

www.sdparks.or

Established in 1946, the County of San Diego Department of Parks and Recreation is dedicated to preserving regionally significant natural and cultural resources, and to providing opportunities for high quality parks and recreation experiences for residents and visitors. County Parks and Recreation maintains more than 90 parks covering over 44,000 acres open year round. For more information on County Parks and Parks Programs, visit www.sdparks.org or call (858) 565-3600. (County Parks, History Archives.)

ON THE COVER: Taken in 1897 by the Pasadena photographer Adam Clark Vroman, this image of the interior veranda at Rancho Guajome shows two Couts family members, Parker Dear and his wife, Elena Couts Dear, peacefully relaxing at the rancho that had been in their family for more than 45 years. (Couts Collection, San Diego County Parks.)

IMAGES
of America

RANCHOS OF
SAN DIEGO COUNTY

Lynne Newell Christenson, Ph.D.,
and Ellen L. Sweet

ARCADIA
PUBLISHING

Published by Arcadia Publishing
Charleston SC, Chicago IL, Portsmouth NH, San Francisco CA

Printed in the United States of America

Library of Congress Catalog Card Number: 2008928805

For all general information contact Arcadia Publishing at:
Telephone 843-853-2070
Fax 843-853-0044
E-mail sales@arcadiapublishing.com
For customer service and orders:
Toll-Free 1-888-313-2665

Visit us on the Internet at www.arcadiapublishing.com

CONTENTS

ACKNOWLEDGMENTS

The authors thank the County of San Diego Department of Parks and Recreation (County Parks) for sponsoring this publication.

All photographs used in this book are from County Parks History Archives unless otherwise noted. We greatly appreciate the help of Chris Travers, Carol Myers, and Jane Kenealy of the San Diego Historical Society (SDHS); Faye Jonason and Connie Knutson of the History and Museums Office and Stan Berryman of the Cultural Resources Program of the U.S. Marine Corps Base Camp Pendleton (USMC); and Beverly Fisher of Rancho Buena Vista Adobe (RBV) for sharing their photographs.

Other photographs used in the book were from the Los Angeles Public Library (LAPL), the Bancroft Library of the University of California at Berkeley (Bancroft), the Riverside County Museum (RCM), the Seaver Center for Western History Research of the Natural History Museum of Los Angeles County (Seaver), the Department of Special Collections of the University of California at Los Angeles (UCLA), the Local History Collection of the Chula Vista Public Library (CVPL), the Anaheim Public Library (Anaheim), the Huntington Library (HL), the Library of Congress (LC), and the California Historical Society collection at the University of Southern California (CHS collection, USC). We want to thank Roy Coox of the Vista Irrigation District for his continued support and encouragement.

Individuals, many of whom are Californio descendants, generously shared their family treasures with us. These people include Chris Wray (CW); Shelley Hayes Caron (SHC); Joe Jacobs (JJ); Alana and Bruce Coons (ABC); Jane Stokes Cowgill (JSC); Sayre Macneil (SM); Pat Laflin (PL); Carol Hendrix (CH); Pamela Richardson Rivas (PRR); Marie Clark Walker (MCW); Virginia Carpenter (VC); and the Couts, Marrón, Hayes, Baumgartner, Richardson, and Mohnike families.

We also are extremely grateful to Melvin M. Sweet, who scanned and organized the photographs used in this book; Donald E. Newell (DEN), for his original photography; Destiny Larberg and Michelle Donley for their invaluable assistance; and Brian Albright and Trish Boaz of County Parks for their support and encouragement. Lastly, we are indebted to the late Mary F. Ward, the first San Diego County Parks historian, for her extensive rancho research collection and her efforts to preserve Ranchos Guajome and Peñasquitos.

INTRODUCTION

The first Spanish colony established in California in 1769 was the mission and presidio at San Diego. From this first settlement, the Spanish and Mexican governments founded presidios, pueblos, and missions, and granted vast amounts of rancho lands to private individuals.

Initially, this frontier area was settled by soldiers, missionaries, colonists, and Native Californians. All of California, including San Diego County, was on the Spanish frontier, which was a great distance from the capitals of Spain and Mexico. Supplies frequently arrived late or not at all. Sometimes soldiers worked for years without pay. People stationed in San Diego were on their own and developed an independent spirit. They called themselves *Californios*.

After 50 years of Spanish rule, the Mexican government replaced the Spanish in 1821. One of the first things they did was take over the lands previously owned by the missions and presidios. These lands were given to people who lived in the area. Rancho grants were awarded to individuals in order to encourage agriculture and to reward soldiers for loyal service.

These original land grants were issued under a loose system that emphasized physical landmarks to establish the boundaries of each grant. Hand-drawn maps of each rancho were the official boundary designations. It did not matter to anyone that the rancho boundaries were vague because there were no fences. Cattle roamed freely across the land.

Ranchos covered the most fertile land in San Diego. Each rancho produced its own grain, vegetables, grapes, fruits, and other foodstuffs, and grazed thousands of head of cattle, sheep, and horses. The dons and doñas, often called *rancheros*, owned the ranches and built large adobe ranch house complexes. Native Americans were servants in the house and filled all the labor positions needed to run a successful ranch. Daily life followed the California tradition of fiestas, dancing, rodeos, and generous hospitality. Weddings and baptisms were celebrated with feasting, games, dancing, and great joy that lasted for days or weeks.

The chief economic activity during this period consisted of exporting hides and tallow. Mexican independence opened California ports to foreign trade and coincided with the expansion of the American shoe industry. Suddenly, cow hides, one of the few items California produced in abundance that could withstand the long transportation by ship to market, were in great demand. By the late 1820s, cattle were raised expressly for their hides and tallow, and approximately 40,000 were exported annually. English and Boston ships carried an estimated 6 million hides and 7,000 tons of tallow out of California between 1826 and 1848.

The rancheros were wealthy not with money but in land and cattle. Merchant ships landed in San Diego loaded with items needed for daily life as well as luxuries. The rancheros used hides and tallow to trade for fine linens, perfumes, china, jewelry, and other luxuries. Money seldom changed hands because the economy of San Diego relied on trade and barter.

These Californios developed a unique, colorful, and independent lifestyle. For more than 40 years in San Diego County, the Californio way of life dominated. The ranchos were the economic mainstay. Many families had two homes—one in Old Town and a ranch home. When the Americans arrived, they brought a new culture and legal system, which resulted in the decline of the rancho system.

When California became a state, Congress established a Board of Land Commissioners to establish the validity of these Spanish and Mexican land claims. It was a process that was expensive, confusing, and foreign to the Californios, most of whom did not speak English. Furthermore, most of the court sessions were held in San Francisco, which put another burden on the southern landowners. Some claims were approved, some rejected, others were not decided until the 1880s, and still others wound up in the courts. Many of the ranchos had long since been sold, split into smaller sections through inheritance or sale, or been subject to fraudulent claims. Many of the ranchos were sold for small amounts of money because the owners did not have money to pay the newly imposed taxes.

Despite the difficulties, many of these Californios were able to adapt to their new life as U. S. citizens. A few were able to make the transition and remained leaders in the new California. Very few remained land wealthy, however, and those that did soon lost their land to taxes or squatters or to the confusing financial and legal system the Americans introduced.

Descendants of these Californios often remained in the state. Their heritage is sometimes romanticized or misrepresented. What remains of their uniquely Californian lifestyle are the adobe houses and some barns, springhouses, and other ranch buildings. A few of these adobe rancho buildings are more than 150 years old and have been restored. Some are open to the public for adults and school children to tour. A few are in private hands. This book will give an insight into rancho life and provide a background for visiting those ranchos that survive.

One

Rancho Santa María de los Peñasquitos

As the earliest Mexican land grant within the present day boundaries of San Diego County, Santa María de los Peñasquitos set a precedent for the land grants to follow. Gov. Luis Antonio Argüello granted one league, or 4,439 acres, to the presidio comandante Capt. Francisco María Ruiz (1754–1839) in 1823. Padres from Mission San Diego complained that Ruiz was taking their land unfairly. They claimed that part of the land had been used for grazing and agriculture. The padres wrote the governor that Los Peñasquitos was a sheep ranch used by the mission every winter. They also had a vineyard and orchard on this land. Their protests seem to have been ignored.

In Spanish, Los Peñasquitos means "little rocks" or "little cliffs." In 1833, Ruiz applied for a second league to extend his property to the west because so much of his land was considered hilly, brushy, and unusable. This time the mission fathers said the ranch augmentation was not their property but that of the presidio. The extension, known as El Cuervo, terminated in presidio farming land. This additional land was granted in 1834 to Francisco María Ruiz and his grandnephew Francisco María Alvarado (1794–1860).

By this time, the retired captain Ruiz was elderly and in ill health. A bachelor, he relied on the family of Alvarado. Alvarado was one of the leaders of San Diego. His wife, Tomasa Pico (1799–1873), was also part of a politically active family. The Alvarados and their children lived in San Diego and at the ranch. Ruiz also had a home in San Diego, now known as the Casa de Carrillo, which he deeded to his Carrillo godchildren. When Ruiz died, the ranch continued in Alvarado ownership.

After statehood, Francisco María Alvarado applied to the Board of Land Commissioners for a clear title to the rancho. It was rejected, confirmed by the district court, and appealed to the Supreme Court. A patent for 8,486 acres was finally issued in 1876, long after the death of Alvarado. However, the land continued to be held in the hands of Alvarado's children, Diego and Estéfana.

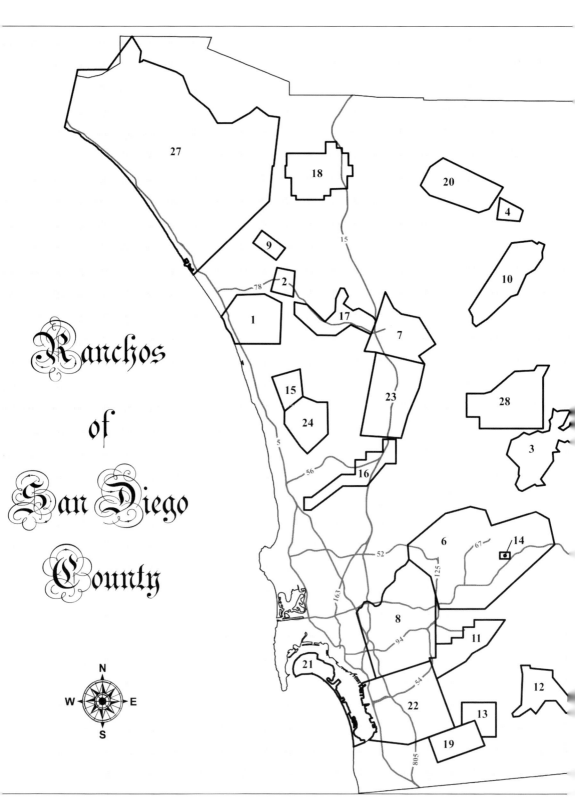

Ranchos

of

San Diego

County

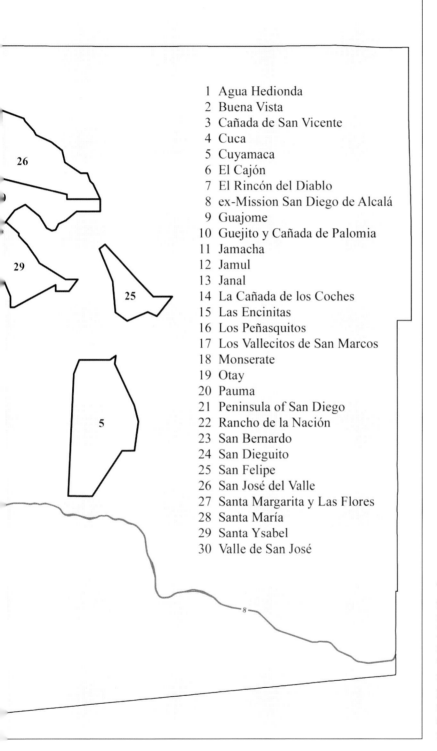

1 Agua Hedionda
2 Buena Vista
3 Cañada de San Vicente
4 Cuca
5 Cuyamaca
6 El Cajón
7 El Rincón del Diablo
8 ex-Mission San Diego de Alcalá
9 Guajome
10 Guejito y Cañada de Palomia
11 Jamacha
12 Jamul
13 Janal
14 La Cañada de los Coches
15 Las Encinitas
16 Los Peñasquitos
17 Los Vallecitos de San Marcos
18 Monserate
19 Otay
20 Pauma
21 Peninsula of San Diego
22 Rancho de la Nación
23 San Bernardo
24 San Dieguito
25 San Felipe
26 San José del Valle
27 Santa Margarita y Las Flores
28 Santa María
29 Santa Ysabel
30 Valle de San José

This book features 10 of the many San Diego County ranchos that were confirmed to their owners, plus two other ranchos that were significant during the rancho era.

This artistic rendering shows what archaeologists believe to be the earliest rancho buildings at Los Peñasquitos. Archaeological studies proved the presence of two single room adobe structures and a ramada. The ramada was where food was cooked and laundry was washed. Three walls from one of the adobes remain in the oldest wing of the ranch house.

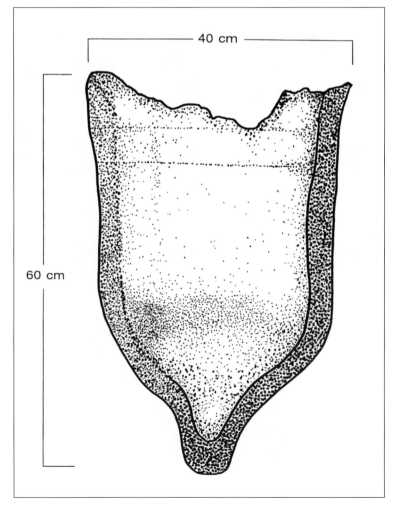

The most remarkable artifact found by archaeologist Dr. Susan Hector was an olive jar buried upright in the ground of the kitchen ramada. It was used to hold water. Only one other vessel like this was found on the West Coast. This jar dates from the mid-1700s and was used to ship oils, wine, and other foods.

In 1857, a reporter riding the San Antonio–San Diego Mail Stage wrote, "We stopped for dinner near a house where dwelt a fair maiden, of whose beauty I had heard even at Sacramento. We . . . saw the fair Stephana, and were regaled with a bottle of native wine, a dish of olives, etc." Stephana was Estéfana Alvarado (1840–1926), daughter of ranch owner Francisco María Alvarado. (Seaver.)

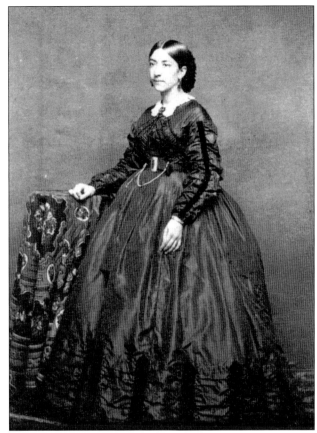

In 1859, Estéfana Alvarado married George Alonzo Johnson (1824–1903), a wealthy entrepreneur who ran steamboats on the Colorado River delivering food and freight to the army. Their wedding fiesta lasted one week and was open to everyone. The Johnsons built the ranch house that can be seen today. Estéfana bore nine children. Sadly, only two children survived to adulthood; five died in infancy and two more as teenagers. (UCLA.)

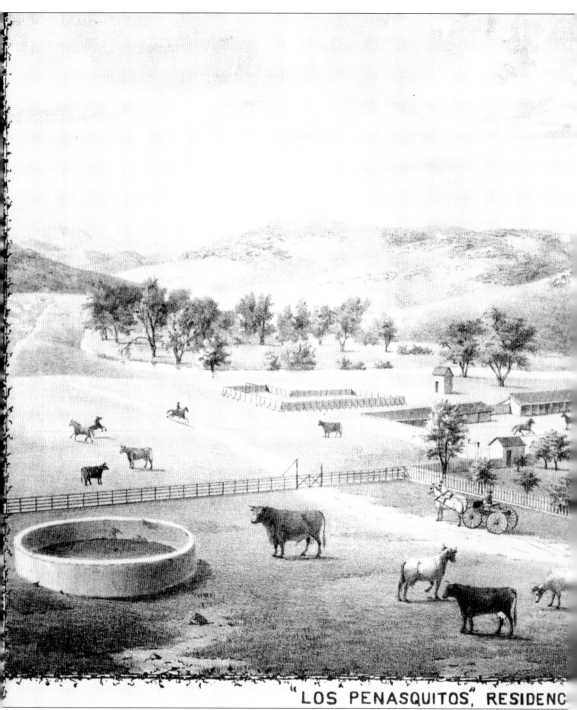

"LOS PENASQUITOS", RESIDENC

Promotional local history books like the one about San Diego by Wallace W. Elliott were used to entice residents and tourists. This 1883 lithograph of Rancho Peñasquitos, then owned by Jacob Shell Taylor, shows the property to advantage. A newspaper article about the ranch stated: "There is much that is ornamental, such as three cemented ponds, stocked abundantly with gold fish and carp, eight fountains, arbors, rookeries, etc. All the land embraced in the 20 acres is

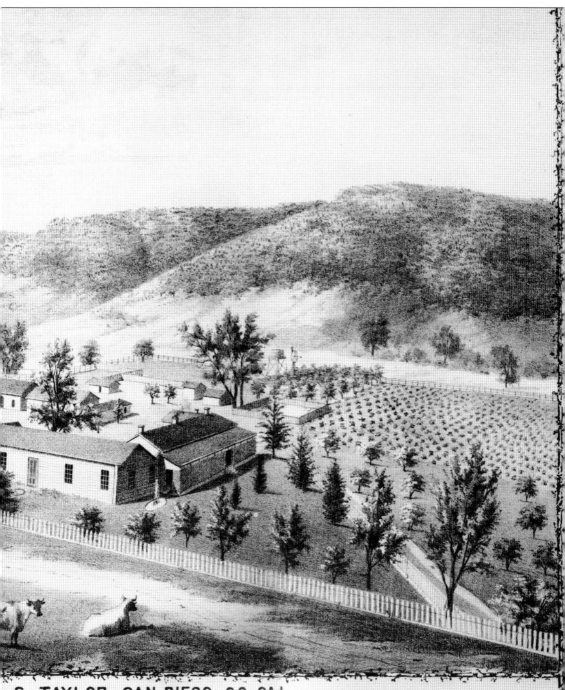

S. TAYLOR, SAN DIEGO CO. CAL.

under a high cultivation, in orchards, vineyards and vegetables, among which may be mentioned oranges, pears, peaches, apricots, apples, figs, olives, lemons, limes, plums, guavas, strawberries, raspberries, blackberries, raisin, wine and table grapes, bananas, nectarines, melons and all kinds of vegetables. There is also a large apiary on the place, which produces largely of the San Diego honey." (RCM.)

15

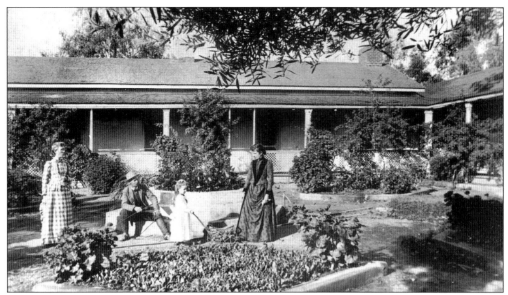

The Johnsons split their time between the ranch and their Colorado River home until Captain Johnson had financial difficulties and various absentee ranchers took over. The Sandford family lived there from 1889 to 1895 as caretakers. They ran 850 head of cattle and 300 horses, and had 5,000 fruit trees. Shown are Henry Sandford; his mother-in-law, Harriet Furman Leonard, to the left; his daughter, Alice; and his wife, Belle, on the right. (CH.)

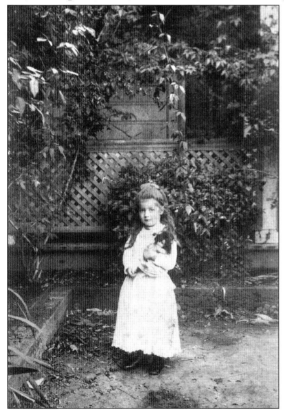

Alice Esther Sandford was four years old in 1892 when this picture was taken of her in the courtyard of Rancho Peñasquitos. She was a lifelong resident of San Diego. (CH.)

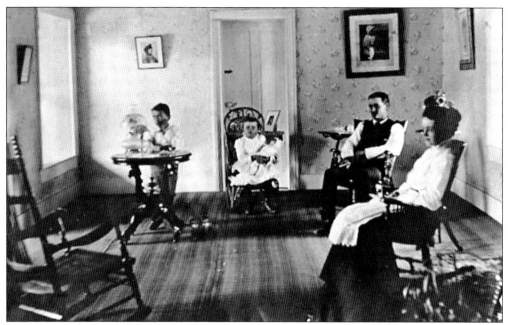

This 1900 photograph of the ranch house interior shows the Rennie family: (from left to right) Paul, Violet, William, and Francis. William was another ranch foreman for an absentee owner. Paul died at the ranch house of meningitis shortly after this picture was taken. (PL.)

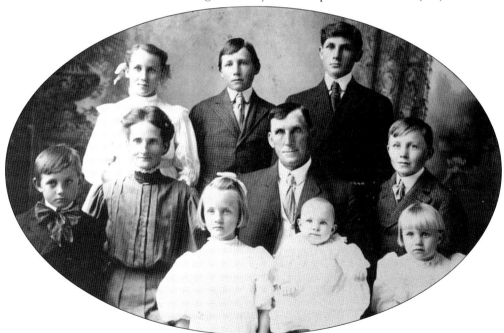

In 1910, Charles F. Mohnike bought Rancho Peñasquitos for $100,000. He was married with a large family. They built a Victorian house in Chula Vista, surrounded it with rare trees and semi-tropical shrubs, shade arbors, and croquet and shuffleboard courts. Spending summers at Peñasquitos, the family hired cowboys to care for 800 horses and 1,200 Hereford cattle. Mohnike tended the large citrus orchards on the property. (Mohnike.)

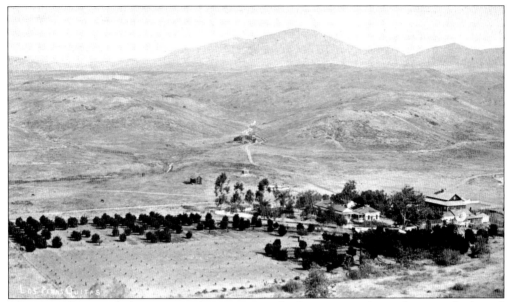

This 1889 photograph shows major changes at Rancho Peñasquitos. A new barn was built, and the kitchen area was expanded with a Victorian-style building.

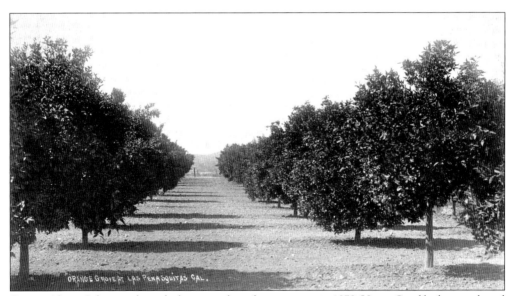

George Alonzo Johnson planted a large number of orange trees in 1878. Henry Sandford remembered that, in the 1890s, the five acres of orange trees produced such abundance that he shipped three carloads of fruit three times in one season with a profit of $2,700.

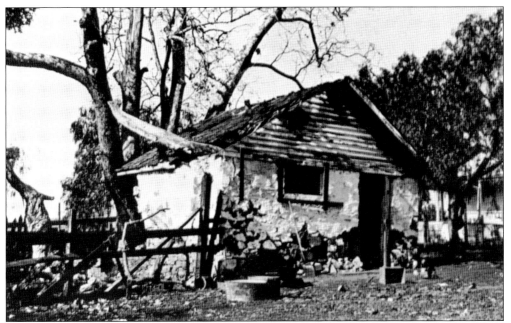

An artesian spring bubbles up at Rancho Peñasquitos at a stable rate and temperature year-round. Occupation of a nearby Native American site has been radiocarbon dated to 7,400 years ago. It is believed that the prehistoric Kumeyaay people stayed here because of the spring. Today the flowing spring is surrounded by a rock springhouse. The springhouse, of unknown origin, was restored in 2001.

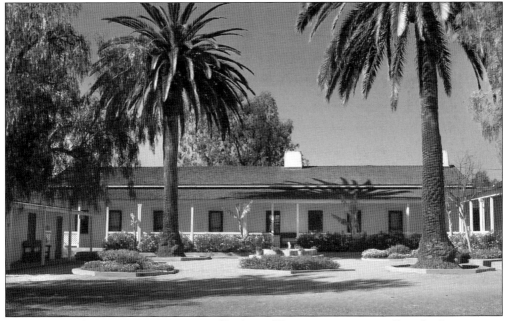

The County of San Diego Department of Parks and Recreation now owns Rancho Peñasquitos. Open to the public as part of a large preserve, this restored adobe provides valuable information about San Diego history to many fourth graders. Weddings, fiestas, and various public events are held at the rancho every year.

Los Peñasquitos Canyon served as a favorite camping and riding spot in the early 1900s, much as it does today. The canyon was also a major route to San Diego from the eastern part of the county. (ABC.)

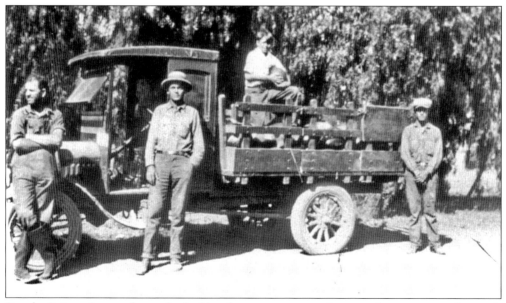

Rancho Peñasquitos employees, both old and young, transported watermelons grown on the ranch to nearby markets. The ranch was well known for its abundant crops.

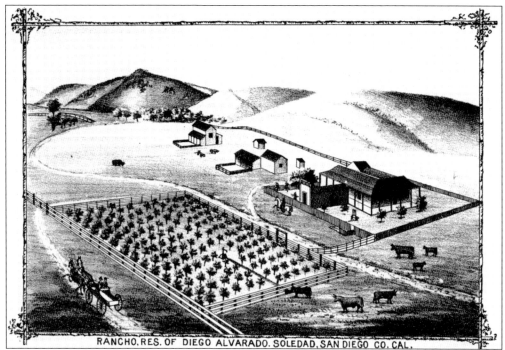

RANCHO, RES. OF DIEGO ALVARADO. SOLEDAD, SAN DIEGO CO. CAL.

Los Peñasquitos Canyon is six miles long with an Alvarado adobe at each end. Francisco María Alvarado deeded all the ranch property to his son, Diego Alvarado (1836–1919). In turn, Diego sold half to his sister Estéfana and her husband, George Alonzo Johnson. Diego built another ranch house on the western part of the property called *El Cuervo* (the Crow or Raven). This 1883 lithograph shows his rancho. The same adobe ranch house shown below in 1937 is now in ruins. It is owned by the City of San Diego. (Above, RCM; below, SDHS#9417-1.)

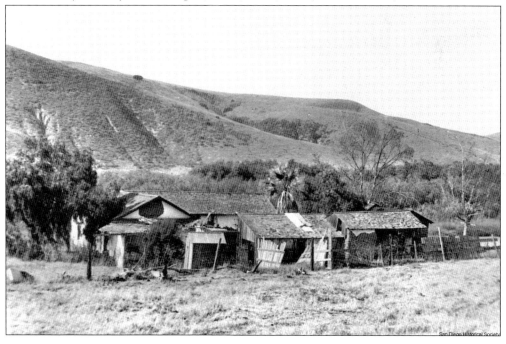

San Diego Historical Society

21

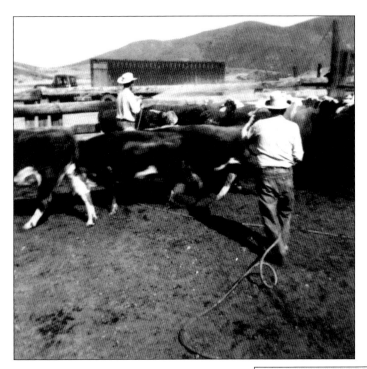

Cowboys Kenny Rimbach and Hank Keeney spray cattle on the ranch in this 1960 photograph. Cattle roamed in the Los Peñasquitos Canyon well into the 1980s.

This illustration shows the Circle A brand, believed to have belonged to the Alvarados of Peñasquitos. In 1983, near the site of the old Alvarado adobe in Old Town San Diego, a deteriorating Circle A brand was excavated. In 1860, this brand was registered in San Diego to Alvarado's son-in-law George A. Johnson. For more than 20 years, another brand has been mistakenly used to represent the rancho.

Two

RANCHO GUAJOME

Rancho Guajome was named after the Luiseño Indian village *wakhavumi*, meaning "place of the frogs." After mission secularization, Mexican governor Pío Pico awarded 2,219 acres to Luiseño brothers Andrés and José Manuel. They sold their land to Abel Stearns, a wealthy Los Angeles merchant. Stearns presented the land to his sister-in-law, Ysidora Bandini, as a wedding present. She married the dashing Cave Johnson Couts, an American army officer.

Beginning in 1853, the young couple built their ranch house. Four miles away, the abandoned Mission San Luis Rey provided building materials. Using Luiseño Indians as a labor force, Couts transferred huge hand-hewn sycamore beams and roof tiles to the ranch. Rancho Guajome was built in the traditional Californio style with four wings enclosing a central patio. The ranch house contains 28 rooms and covers 7,000 square feet. It is a superb example of Hispanic American domestic architecture.

Cave and Ysidora, their eight lively children, and for a time, a schoolmaster, a resident priest, and household servants lived at the rancho. The family wing opened onto a courtyard filled with trees, plants, and fragrant flowers. A second courtyard served the Native American servants and vaqueros. Their rooms opened onto a dirt courtyard they shared with buggies, a blacksmith shop, and the tack room. In 1867, Couts expanded the ranch house by adding a chapel, a new kitchen wing equipped with cast iron range, and a bathing pool. The family even installed window glass.

The couple became a legend for their gracious hospitality, making Guajome a favorite overnight stopping place for travelers. When Couts died suddenly in 1874, Ysidora was left with a huge rancho, eight children, servants, and ranch hands. Cave Couts Jr. assisted his mother with ranch management. After her death in 1897, he continued to live at Guajome. He often referred to himself as the "Last of the Dons."

The County of San Diego acquired the ranch house in 1973 and restored it in the 1990s. Because Rancho Guajome is an excellent representation of the Native American, Mexican/Californio, and American history of early California, it is now a National Historic Landmark.

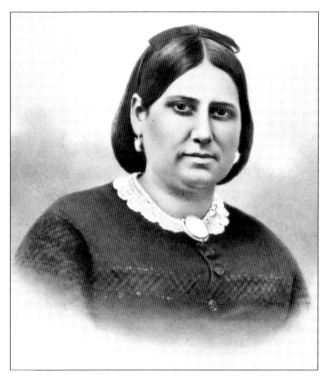

Ysidora Bandini (1828–1897)—beautiful, intelligent, and strong willed—was born in San Diego. Her father was the prominent Juan Bandini, and her mother was María de los Dolores Estudillo. She was raised in San Diego but spent much of her teenage years in Los Angeles with her married sister, Arcadia Bandini de Stearns. Visitors, including U. S. military, raved about her beauty and her hospitality.

Cave Johnson Couts (1821–1874) was born in Tennessee. He received an appointment to West Point in 1838 through the influence of his uncle Cave Johnson, a member of the U. S. House of Representatives. Cave graduated in 1843 as a brevet second lieutenant. Arriving in California in 1849 at the end of the Mexican-American War, he served as a military escort for members of the boundary commission.

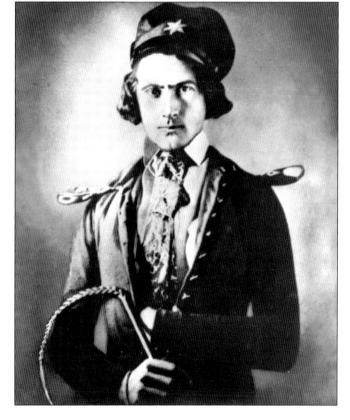

From the beginning, Cave Johnson Couts saw the promise of San Diego. He invested in livestock and bought land in and near San Diego with the help of Juan Bandini. In the first tax list of 1850, he was assessed for property located at La Playa, San Diego, and Soledad. Even after resigning his military commission, he served his community in a number of official positions.

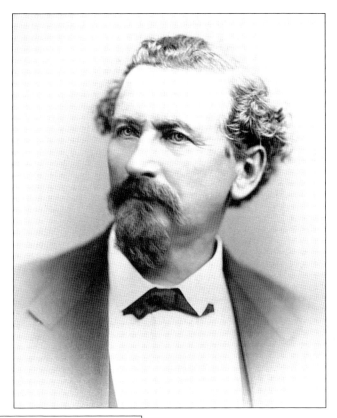

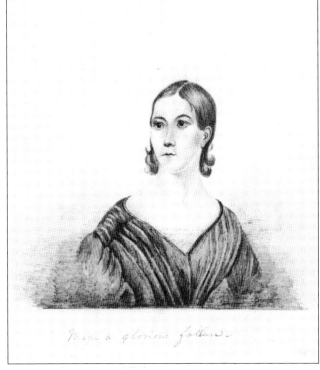

Cave Couts made this 1849 drawing of Ysidora while he was a guest at her father's home. He did not think he captured her beauty and charm, and wrote on the sketch, "Made a glorious failure." Cave and Ysidora married in 1851 at the Casa de Bandini. The couple set about turning her brother-in-law's gift of Guajome into their home, as well as a successful business operation. (HL.)

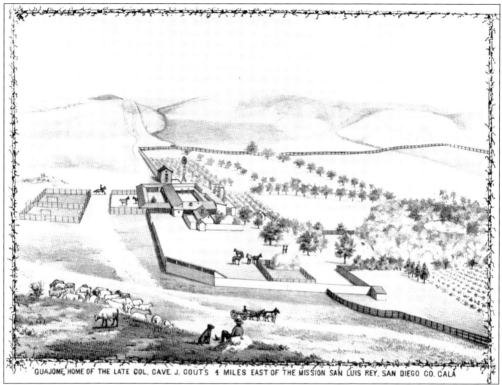

This 1883 drawing of Rancho Guajome from the promotional book about San Diego by Wallace W. Elliott showed the basic layout of the ranch, including the large house, chapel, outbuildings, corrals, and orchards. The washing place is in the right center. (RCM.)

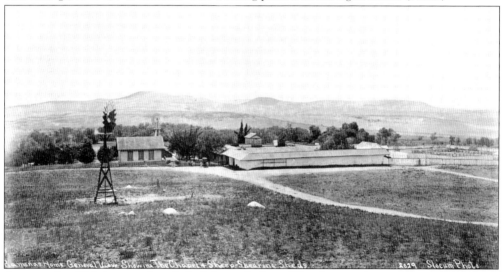

Compare this 1895 photograph with the lithograph above. The photograph was captioned "Ramona's Home General View Showing the Chapel and Sheep-Shearing Sheds." Helen Hunt Jackson wrote the romantic novel *Ramona* to alert people to the terrible health and living conditions of Southern California Native Americans. Jackson spent some time at Rancho Guajome and incorporated some of her ranch experiences into her story.

In 1867, Cave Couts expanded the ranch house by adding a new kitchen wing. This large *horno*, or oven, shown in the background, was built to help feed the growing number of people who worked on the ranch or stopped by to take advantage of the Couts's hospitality. Ysidora was known throughout the region as a cordial hostess.

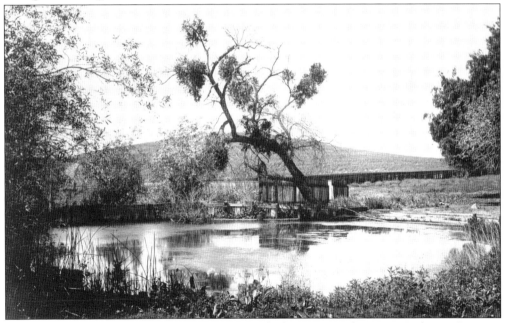

The washing place at Rancho Guajome was made famous in Helen Hunt Jackson's *Ramona*. The washing place, described as "cool and shady even at noon and the running water always full of music," was where the fictional characters Ramona and Alessandro met, talked, and fell in love. (SHC.)

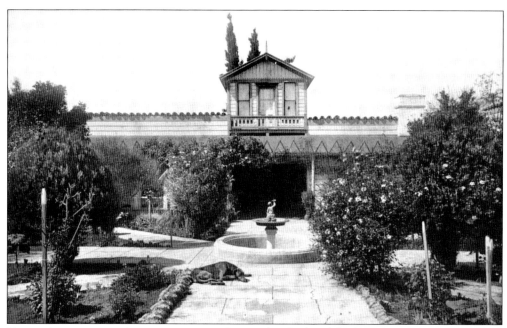

Native American attacks were a concern for people who lived far from San Diego. Ysidora had her husband designed the rancho so that she and her family could be enclosed at night in the family courtyard without fear. Exterior doors were locked and windows were shuttered. This security allowed them to carry on family activities after dark in comfort. There is no evidence that Native Americans ever harassed the family.

This was the working courtyard. The blacksmith shop was located through the wooden gates. Ysidora's buggy, shown under the tree, has been restored and is on display. A tack room was also found in this courtyard. The *majordomo*'s, or foreman's, room was in one corner of this courtyard, as were bedrooms for the servants. One fireplace served all the Native American servants. (SDHS#80:7953.)

Ysidora was a devout woman. As a young girl, she attended church services frequently. Guajome was a long distance from any functioning church. Mission San Luis Rey was abandoned. Cave built the original chapel at the rancho for Ysidora about 1868 so that they could hold religious services. For a short time, a priest lived at Guajome. Occasionally, priests stopped at the rancho, performing baptisms and weddings. (SDHS#12472.)

The chapel's interior was photographed in 1897. The ornate furnishings included a set of chromolithograph Stations of the Cross gracing the walls. Apparently, Ysidora understood that her children, as is often the case, did not follow her practice of frequent church services. She was explicit in her will that all items from the chapel's interior were to go to a refurbished Mission San Luis Rey upon her death.

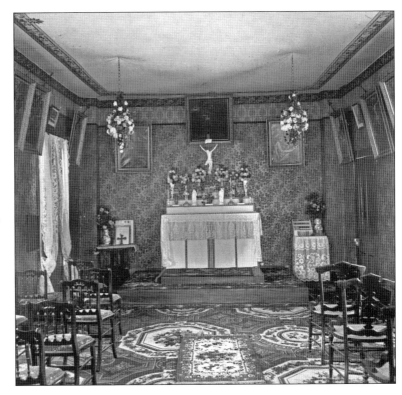

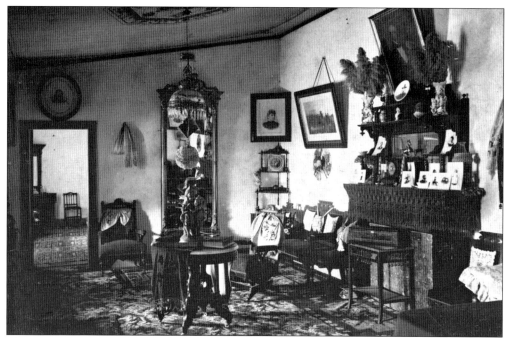

This 1897 photograph shows the parlor as decorated by Ysidora Bandini de Couts. Family portraits graced the walls and mantel. A decorated *manta* ceiling was overhead. A manta is a piece of cotton or linen cloth that covered the ceiling in many rancho buildings to prevent dirt from falling from the roof. Often, plaster was applied so that it lasted longer and made the room brighter.

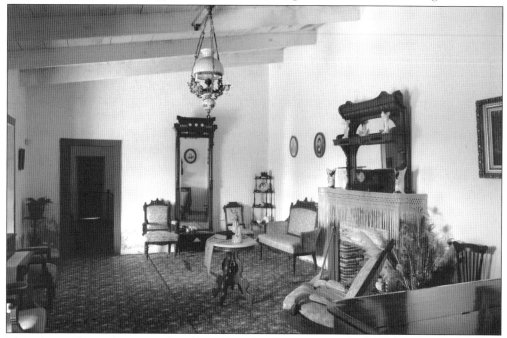

This picture shows the restored parlor at Rancho Guajome as it looks today. Rancho docents have used the earlier photograph to redecorate the room using antiques that match what was originally there. Future plans include replacement of the manta ceiling. (DEN.)

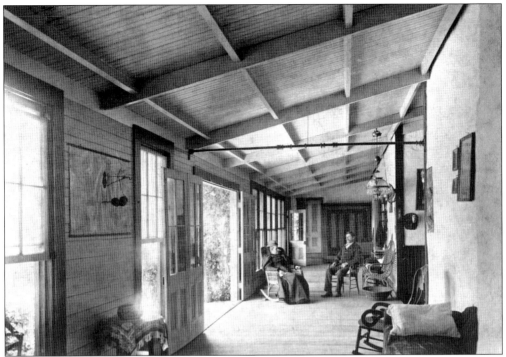

Parker Dear and his wife, Elena Couts Dear, are pictured in this 1897 photograph of the interior veranda. The doors open onto the family courtyard. A modern photograph of the same room (below) shows the restoration by the Rancho Guajome furniture committee. When visiting, note that the staircase in the modern photograph was not there in the 1897 photograph. The staircase was moved from the outside to the inside in the 1920s restoration. (Below, DEN.)

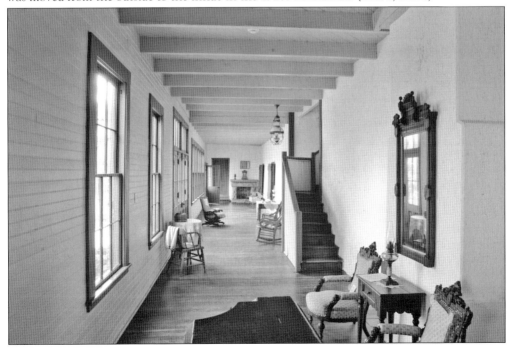

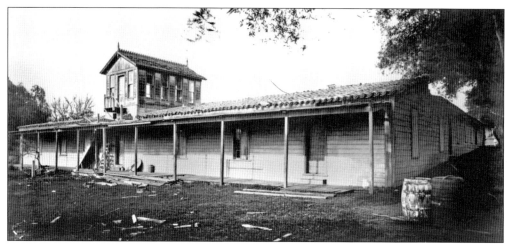

The sewing room over the main portico was built in 1886 by Cave J. Couts Jr. for his bride, Lily Bell Clemens, and is shown in this 1915 photograph of the west exterior. In 1924, Cave J. Couts Jr. made major changes to a rapidly deteriorating ranch house. This remodeling included a new facade (as seen in the 1957 photograph below), guest apartments, bathrooms, garages, sheds, and updated electrical wiring and plumbing. This 1924 restoration took a dilapidated ranch house and garden and converted them into a colorful mission-revival tourist attraction. Cave J. Couts Jr. basked in his new reputation as the "Last of the Dons." (Above, SDHS#16299-1.)

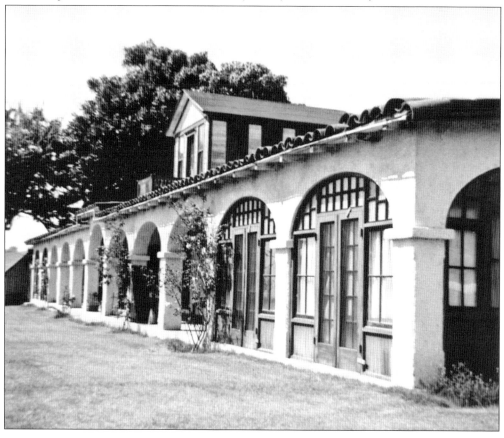

Cave J. Couts Jr. (1856–1943) spent his entire life at Guajome. As one of the last of the Californio dons, he had no occupation and no income. Economics were always a serious concern as he struggled to maintain a large home that needed repairs. One short-lived occupation as a surveyor helped with finances. He laid out the streets of Oceanside. His equipment is on display at the ranch house.

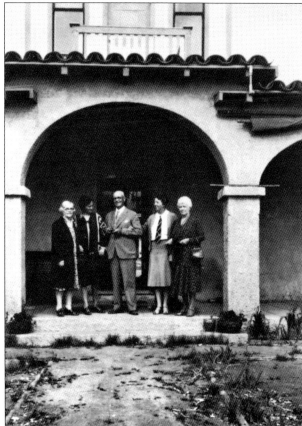

This 1924 photograph shows Cave J. Couts Jr. in his newly renovated ranch house. Ida Kunzell Richardson (1898–1972) is second from the left. The other women are unidentified. Ida served as housekeeper and companion to Cave Jr. beginning in 1918.

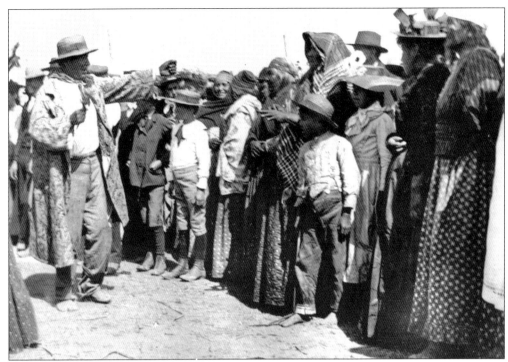

The Luiseño Indians were an integral part of Rancho Guajome. The Village of Guajome was near the rancho. The Luiseño worked as house servants and cooks, vaqueros, sheep shearers, and construction or farm hands. The 1860 census documented 18 Native Americans at Rancho Guajome and 118 in the Luiseño village at Mission San Luis Rey. This photograph shows some Luiseño Indians dressed for a celebration at the mission. (VC.)

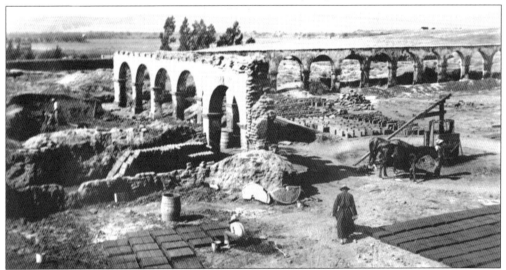

This photograph shows the restoration of Mission San Luis Rey by the Franciscan priests. Originally built in 1798, the mission, once called the "King of the California Missions," was abandoned following secularization in 1834. When Cave Couts built the ranch house, he used many items from the decaying mission. The mission was restored beginning in 1892 and held its first service in 40 years in 1893. (SHC.)

The hand-hewn beams in the blacksmith shop came from Mission San Luis Rey. They were removed from the mission buildings, placed on carts or wagons, and taken four miles to Rancho Guajome. The wooden barrel held water used by the blacksmith. Native American labor helped Cave and Ysidora build their dream home.

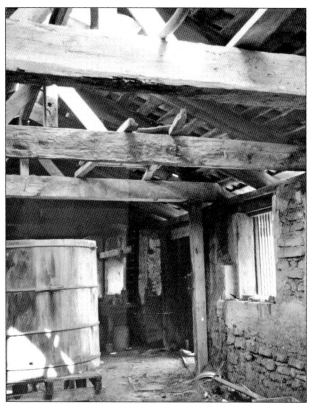

In order to restore the ranch house to its original appearance, old-fashioned construction techniques were used. This photograph shows adobe bricks in their forms, drying in the sun. Once dried, these bricks were used to restore ranch house walls that had fallen down.

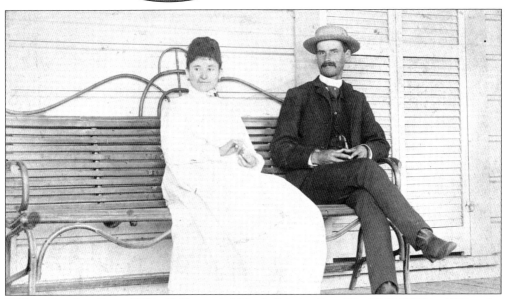

This wonderful family photograph shows Cave and some of his children about 1866. Cave is standing. The Couts children, from left to right, are Ysidora, William, María Antonia, Elena, Nancy Dolores, Cave Jr., and Robert. Tragedy struck the family in 1868 when Nancy Dolores, named for her two grandmothers, sickened and died at school in Los Angeles. The first Couts child, Abel Stearns Couts, died at the age of three.

William Bandini Couts (1854–1935) married María Cristina Estudillo (1858-1922) in 1877 at the Guajome chapel. Their marriage was noted as being one of the largest wedding feasts held in the county. Following the ceremony, everyone ate a sumptuous supper and danced to the wee hours of the morning. Guests then went to Santa Margarita for a christening, followed by more food, dancing, and games before returning to Guajome.

Thomas Chalmers Scott (1844–1898) was a successful attorney and businessman who traveled the world but preferred to live in California. He often worked for Cave J. Couts. In 1874, shortly after Couts died, he married María Antonia Couts in the Guajome chapel. After the Couts estate was probated, the Scotts received the north half of Rancho Buena Vista. The Scotts had 11 children, but two died in infancy.

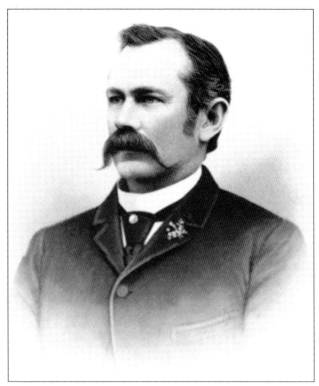

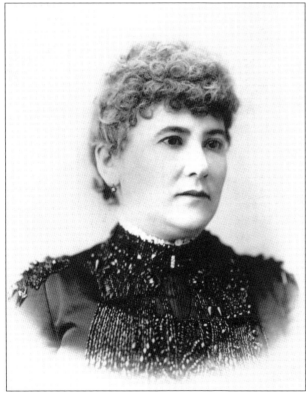

María Antonia (Tonia) Arcadia Couts (1853–1936) was noted as being well educated, brilliant, and beautiful in face, form, and character. She sang and played the guitar. She was as strong willed as her mother. It is possible that the main character in the book *Ramona* was patterned after Tonia because both she and Ramona ran away from home with men not of their station. (SDHS#12469.)

Robert Lee Couts (1864–1920) was named after Robert E. Lee, who was a classmate of Cave Couts at West Point. Robert's life was full of accomplishments, and he was described as a frontiersman and a businessman. In 1888, he was proprietor of a livery stable and truck company in Oceanside. Robert and his family lived for a time at Rancho Guajome and then at Rancho Buena Vista.

Susan Virginia Thompson (1865–1923) married Robert Lee Couts in 1882. Susan's mother was a member of the Californio De La Osa family of Rancho Los Encinos, where she spent her earliest years. Susan and Robert had five sons and five daughters, but two girls died in infancy. Two sons met with violent deaths—one was murdered, and one died in the line of duty as a constable.

Elena (Helen) Irene Couts (1862–1952) was married to Parker Dear in 1881 at Guajome by Fr. Antonio Ubach, who was considered to be the model for Father Gaspara in *Ramona*. The Dears had five sons. At least one daughter died in infancy. After spending years as successful ranchers, the couple moved to the Los Angeles area. In 1924, they toured Europe for more than five months. (SDHS#10861-9.)

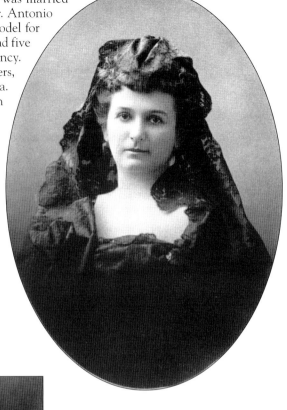

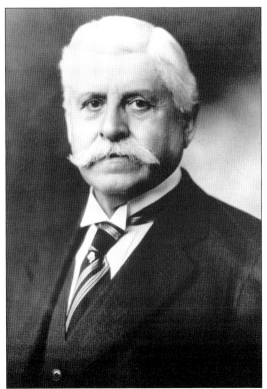

Parker Dear (1859–1939) was born in Liverpool, England. The Dears owned the 47,000-acre Santa Rosa Rancho in Riverside County in the 1880s and 1890s. Parker Dear provided meat to the California Southern Railroad workers in 1881 and 1884, and, consequently, was successful when other ranchers suffered from a severe drought. Every May they entertained guests, some years hosting 2,000 people, with a large sumptuous barbecue. (SDHS#10861-8.)

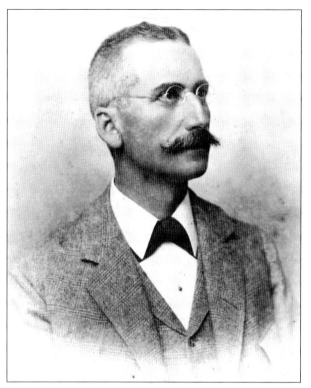

Cave Johnson Couts Jr. (1856–1943) assisted his mother in running Guajome until her death in 1897. In that year, Cave was divorced from his wife, Lily Bell Clemens. He spent the rest of his life on the ranch. In the 1920s, using an inheritance from his Aunt Arcadia, he restored the dilapidated ranch house and chapel, and, in 1930, remodeled his grandfather's Casa de Bandini in Old Town.

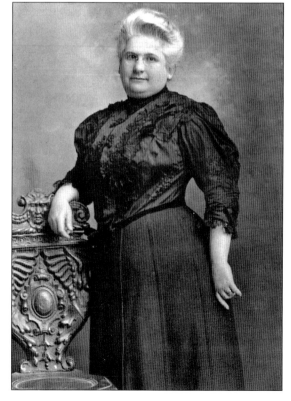

Ysidora (Dora) Forster Couts (1860–1952) married William D. Gray in 1889 at the Guajome chapel. In a sensational series of events, William took their only child, Chalmers Scott, at the age of five, to Virginia. Dora accused him of kidnapping. The abduction and cross-country train ride was reported in many newspapers. Divorce proceedings followed, and Dora was given custody of their son. She married Judge George H. Fuller in 1905. (SDHS#18235-30.)

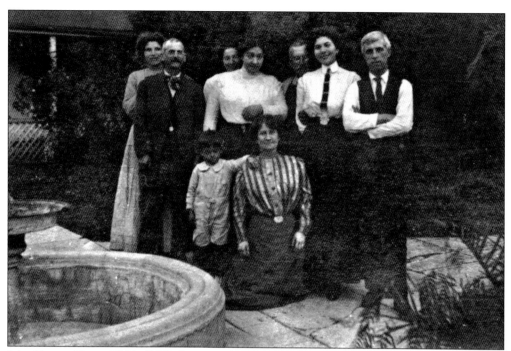

John Forster Couts (1866–1935), shown at the far left with members of the Couts, Veal, and Wolf families, was named for his father's closest friend, John Forster of Rancho Santa Margarita. Married to Susan Irene Gurnett in 1887 in Oakland, he had two sons and a daughter. He worked at the First National Bank and was considered the best baseball pitcher in the bank leagues.

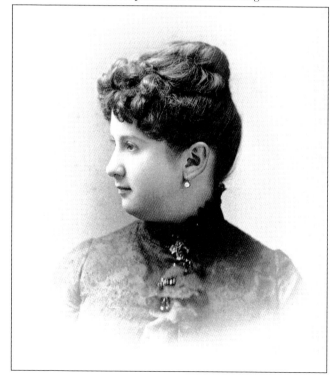

María Carolina Couts (1868–1944) married her cousin John Bandini Winston in 1887 at the chapel at Guajome. They had two daughters and a son. Carolina's mother, Ysidora, and John's mother, Margarita, were half sisters, daughters of Juan Bandini. (SDHS#89:17384-24.)

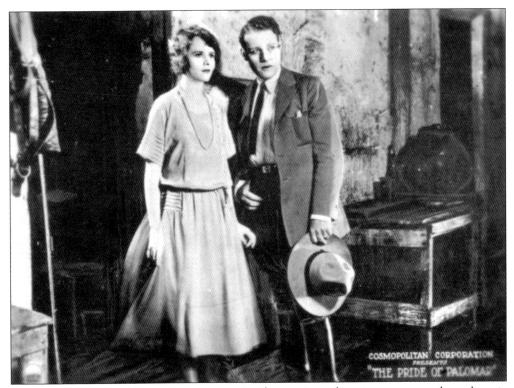

Rancho Guajome provided a picturesque setting for a variety of movies, commercials, and music videos. In 1922, the book *Pride of Palomar* by Peter B. Kyne was made into a movie of the same name using the rancho as a backdrop. Cave J. Couts Jr., often titled the "Last of the Dons," encouraged such use as a tribute to the building and its history.

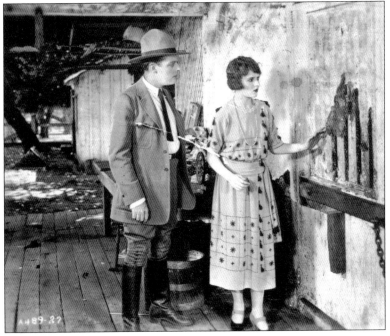

Actors starring in this silent film were Forrest Stanley and Marjorie Daw. Cave Couts Jr. was paid $500 for the use of his home. He also had many of the cast and filmmakers for dinner in the Rancho Guajome tradition. One diner noted that they ate on a 1840s table.

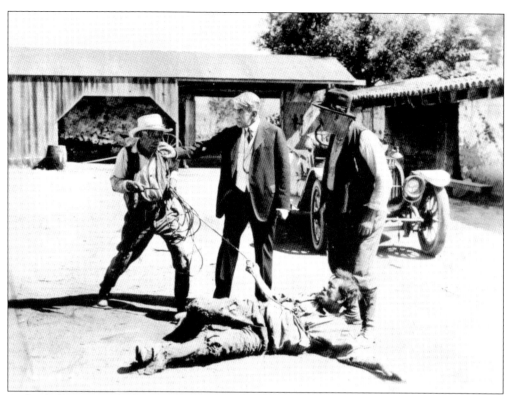

In the dedication to the book, Peter Kyne wrote that, little did Señor Couts know "that his pride of ancestry, both American and Castilian, his love for his ancestral hacienda at the Rancho Guajome, and his old-fashioned garden with the great bougainvillea in flower were necessary to the production."

Pride of Palomar was made before Cave J. Couts Jr. restored Rancho Guajome in 1924. Note the peeling plaster and exposed adobe bricks in this 1922 photograph. The pepper tree in the corner is thought to have been grown from a cutting from the original pepper tree brought to California by the padres.

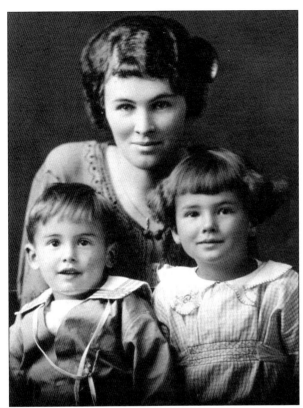

Ida Richardson was housekeeper, secretary, and hostess for Cave J. Couts Jr. at Rancho Guajome. Pictured with Ida are her children, Earl and Belda Richardson. Cave Jr. deeded the rancho to Ida upon his death because of her love for the ranch, because it was her home for more than 20 years, and because of her loyalty in caring for him. The County of San Diego acquired the ranch from Earl Richardson in 1973. (Both, PRR.)

When the County of San Diego acquired Rancho Guajome in 1973, much of the building was in disrepair. This picture from the carriage courtyard shows the entrance gate to the ranch house when County Parks began the restoration. The tile roof is missing over the tack room (to the left) and the *majordomo's* room (on the right).

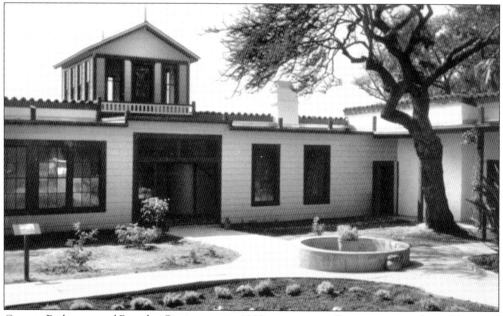

County Parks restored Rancho Guajome to its 1880s appearance. Rooms are complete with period furnishings, some original to the building. It is a popular venue for weddings and celebrations. Docents offer tours to school children and the public. Rancho Guajome is one of the most elegantly restored adobes in San Diego County.

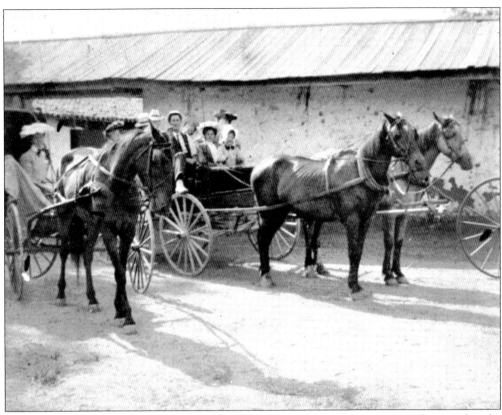

Family outings were popular with Couts family members. They often went to other ranchos for celebrations or to visit relatives. Ysidora's siblings and their families, plus assorted cousins and friends, often visited from Los Angeles or from Baja California.

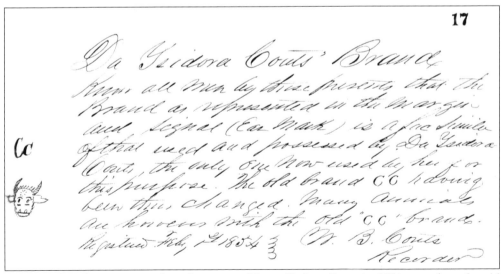

The "Cc" brand was registered in the name of Doña Ysidora Couts in 1854 to replace the old "CC" brand, as shown in this entry from San Diego County's Brand Book One. Her brother-in-law W. B. Couts was county recorder. Cattle brands were often registered in a woman's name.

Three

RANCHO BUENA VISTA

The homes of the Californio rancho families were usually made from adobe bricks. Earthen structures are used worldwide and are comfortable homes that last for generations. Rancho Buena Vista illustrates how such a building, when well maintained, can last for more than 150 years.

This rancho was once a part of the vast complex of Mission San Luis Rey grazing lands. The original Buena Vista land grant of 1,184 acres was issued in 1845 by Gov. Pío Pico to Felipe Subria, a Luiseño Indian. Mexican law recognized Native Americans as citizens, and some small land grants were awarded to Christianized Native Californians. Subria; his daughter, María de la Gracia; her husband, William Dunn; and subsequent owners Jesús Machado and Lorenzo Soto built small adobe homes. The property changed hands many times until Cave Johnson Couts bought it in 1866.

Cave Couts upgraded the ranch house and the property. He covered the land with cattle while many of his adult children stayed in the ranch house. Following his death in 1874, his widow, Ysidora, gave the rancho to her daughter María Antonia as a wedding present. María Antonia and her husband, Chalmers Scott, remodeled the adobe, attached two of the original buildings, planted citrus orchards and a vineyard, and entertained lavishly. Eventually, the Scott family moved to San Diego, and they deeded the rancho to María Antonia's sister Ysidora Couts.

Harry Pollard, a silent screen actor and director, and his wife, Margarita Fischer, a popular silent screen star, bought the adobe in 1931. They loved the beautiful gardens and orchards, and expanded them. Although Pollard died in 1934, Margarita lived and entertained there for 20 years. Comments from a Pollard guest book show that visitors greatly enjoyed the building and grounds. Other owners elegantly maintained the ranch house, continuing the tradition of entertaining family and friends.

Owned by the City of Vista, Rancho Buena Vista Adobe is an historic treasure for residents to share and protect for future generations. It continues to be a popular venue for parties, weddings, and other events. School children visit the adobe each year to experience California history.

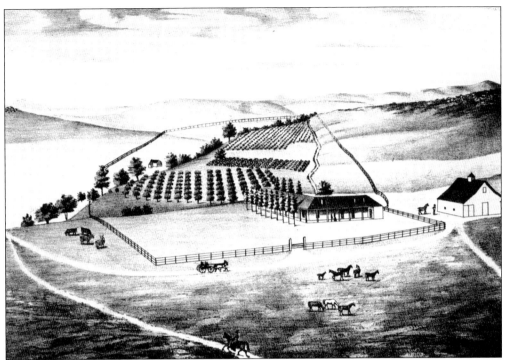

This 1883 lithograph shows beautiful Rancho Buena Vista as an accumulation of many people's hard work. The ranch house was built in stages, and the orchards and vineyards were also planted by various owners, including the well-known orchard of the first owner, Felipe Subria. The Couts family owned the rancho when this lithograph was completed. (RCM.)

Buena Vista became a second home to Cave Couts Jr. and his sisters María Antonia Scott and Ysidora Fuller and their families. Great herds of cattle and sheep grazed the hillsides while everyone rode fine horses. There was an abundance of food, and the Californio hospitality was unsurpassed. This photograph shows the ranch house and courtyard in the early 1900s when Ysidora Couts Fuller owned the ranch. (SDHS#12481-4.)

Wealthy owners saw the value of Rancho Buena Vista and kept the buildings and the grounds in good repair. Jack Knight bought it in the 1920s and upgraded the kitchens and baths. Harry Pollard and his silent film star wife, Margarita Fischer, bought it and furnished it with art treasures from Mexico and Europe. They used Italian tiles on the floors and in the baths. (SDHS#12481-1.)

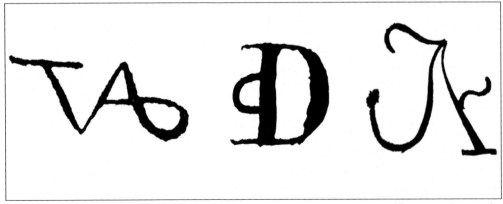

The Buena Vista livestock brands were important in proving ownership of lost or stolen cattle. William B. Dunn, Felipe Subria's son-in-law and a former soldier in Gen. Stephen Kearny's Army of the West, had the first brand. Felipe Subria added the "D" brand, perhaps named for the Dunns. The third brand belonged to Juan Bautista Bandini and was transferred to his niece's husband, Chalmers Scott, in 1875.

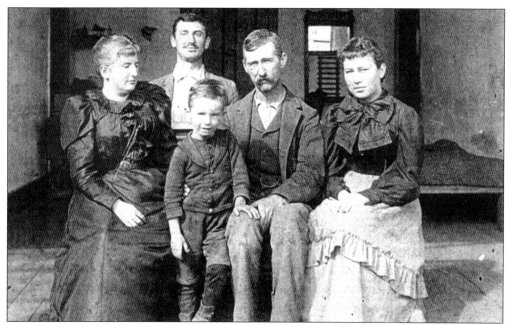

Ysidora Couts Gray, left, is shown here in 1893 with her son, Chalmers Gray (standing), and other family members. Ysidora's life was full of trouble and sorrow. She lost large sums of money, so her sister María Antonia gave her Rancho Buena Vista. Then her son was kidnapped in 1894 by her husband, William Gray, and taken to Virginia. Police rescued him.

Judge and Mrs. George Fuller.

Ysidora married Judge George Fuller in 1905 in Los Angeles. She was said to be a beauty in a family noted for personal attractiveness. The Fullers led a quiet life until George died at Rancho Buena Vista in 1916. Ysidora then lived in Los Angeles until her death in 1952, four years after her son's passing.

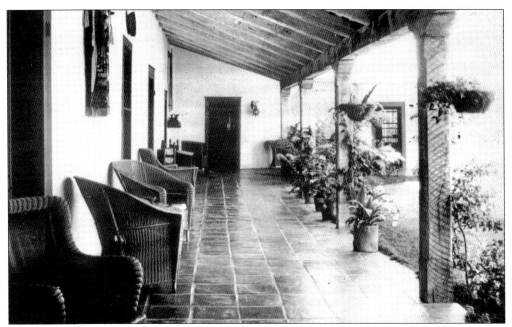

Rancho Buena Vista was an elegant and beautiful residence. Various owners added their individual touches. It was never left to deteriorate as were many other rancho homes. This modern photograph shows the comfortable veranda used by all the owners for entertaining. (RBV.)

Margarita Fischer began her acting career on stage at the age of eight and was dubbed "Babe" Fischer—America's youngest actress. She and her future husband, Harry Pollard, broke into films in 1910 and were married in 1911. In 1914, Fischer became America's most popular star based on a 7-million-vote contest, ranking her above such stars as Mary Pickford. She made more than 90 films. (Pollard collection, RBV.)

Many silent films dealt with the lighter side of life, but the Pollards sometimes confronted serious issues. *The Miracle of Life* (1916) was a melodrama made in protest of abortion. *The Devil's Assistant* (1917) dealt with morphine addiction. *The Pearl of Paradise* (1916) was notable for Fischer's nude scenes. Their most famous production, and Fischer's final film, was *Uncle Tom's Cabin* (1927), where she acted in dark face. (Pollard collection, RBV.)

The Pollards bought the rancho in 1931 and spent $150,000 renovating it. They used the ranch house to entertain many in the Hollywood film industry. After Harry's death in 1934, Margarita continued to live there for another 16 years. Her hospitality was well known. Every Christmas, she had a dinner for estate workers and their families. The rancho was sold to the City of Vista in 1989. (RBV.)

Four

RANCHO AGUA HEDIONDA

With all the legal problems the Californio families faced in trying to hang on to their ranch lands, it is most unusual to find any descendants who still live on the land. Rancho Agua Hedionda, once a huge ranch of 13,311 acres, or three leagues, comprising much of the present city of Carlsbad, still has Marrón descendants living in one of the early adobes.

Juan María Romualdo Marrón (1808–1853) was granted Rancho Agua Hedionda (also known as San Francisco) in 1842 by Mexican governor Juan Bautista Alvarado. As early as 1838, this son of a presidio soldier applied for the land grant. The land had been a sheep ranch for Mission San Luis Rey, but Marrón was politically connected, and his request was approved.

Marrón applied to the Board of Land Commissioners for clear title to his land in 1852, but he died in 1853. His widow, Felipa Osuna (1809–1889), and their four surviving children continued the legal battles. A patent was issued for the ranch in 1872.

The Californio cattle-based economy fell on hard times because of a series of unfortunate circumstances, including drought and a changing market. The Marrón family took a mortgage on the ranch in 1860 for $6,000 for a period of five years from Francis Hinton, a wealthy land and mine owner. When they were unable to repay the money, Hinton took the property, despite having had the use of the land.

Bachelor Hinton died suddenly in 1870, and his ranch foreman, Robert Kelly, took over the property after court battles with Hinton's estranged family. Felipa Osuna de Marrón brought several court cases to try to regain the family land but lost. When Kelly died in 1890, his nine nephews and nieces took over the ranch.

However, one corner of the vast Agua Hedionda was specifically willed to Silvestre Marrón (1827–1906) by his older brother Juan María Romualdo. This portion of the ranch stayed in Silvestre's hands despite a court case brought by Robert Kelly. Although only on a small parcel, Silvestre's adobe home remains today in the hands of his great-great-granddaughter.

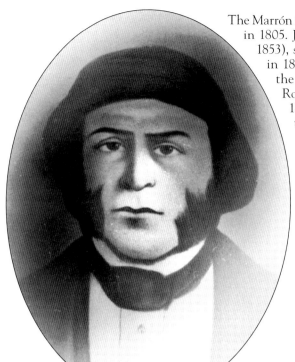

The Marrón family appears first in San Diego records in 1805. Juan María Romualdo Marrón (1808–1853), son of a soldier, married Felipa Osuna in 1834. The next year, her father became the first *alcalde* (mayor), and Juan María Romualdo's father was a councilman. In 1836, Juan María Romualdo was elected to the council. Granted Agua Hedionda in 1842, he still spent time in San Diego as a public official. (Marrón.)

Juan María Romualdo Marrón's adobe ranch house had four rooms built in a straight line with a flat dirt roof and a hard-packed dirt floor. Resting on pole rafters supported by the walls and a long central timber were small sticks, reeds, brush, seaweed, and about a foot of dirt to form the roof. The long porch, shown in this 1937 photograph, served as extended living space. (LC.)

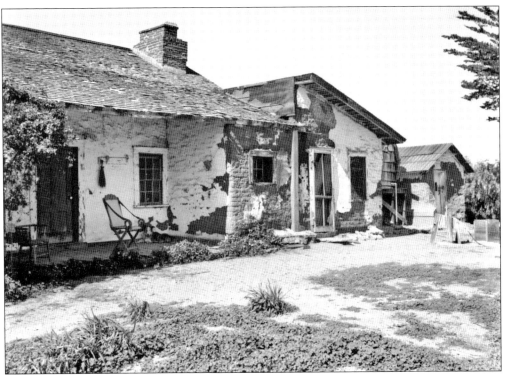

About 1869, after Juan María Romualdo Marrón's family lost control of the ranch, Francis Hinton removed the roof, raised the walls by several feet, added two rooms, and put on a shingle roof. Pine flooring was installed about 1877 by the Kelly family. A large fireplace was probably used for cooking. (SDHS#84:14874.)

This 1937 photograph, taken for the Historic American Buildings Survey, shows wood siding, possibly added in the 1890s, to protect the thick adobe walls from rains and winds from the south. (LC.)

Avaluo. 8

1850 Juan Mª. Marron. Ps Cs

Agua hedionda.

Otubre 30 3 Sitios acres 57 831, in—
 cultivados á 1v ————— 7228 87½
 1 Casa adobe ——— „ 200 „ „
 1 Corral de ganados — „„ 50 „ „
 15 Caballos silla á $50 „ 950 „ „
 „6 Yeguas silla á $20 „ 120 „ „
 63 bestias manada á $7 „ 441 „ „
 „5 Yuntas bueyes á $50 „ 250 „ „
 50, Vacas leche á $25 — 1250 „ „
 1000. Cabezas ganado bronco á $2 12000
Novᵉ 25 1. Casa en esta Ciudad ———„ 2000 „ „
 1. Carro ——————— „„„„ 50 „ „
 1. Carreta del pais ——„„„ 10 „ „
 Dᵉ. de Capitacion $ 8. $24349 87½
 Yᵈ. por milicia — $ 2
 $10

This October 1850 assessment of Juan María Romualdo Marrón's property listed his Agua Hedionda ranch with its cultivated acreage, adobe house and corral, and livestock of various categories (saddle horses and mares, cattle, oxen, milk cows, and untamed cattle). In November, he was assessed for *una casa en esta ciudad* (his San Diego home), his *carro* (wife Felipa's buggy), *una carreta del país* (domestic cart), and poll and military taxes. (SDHS.)

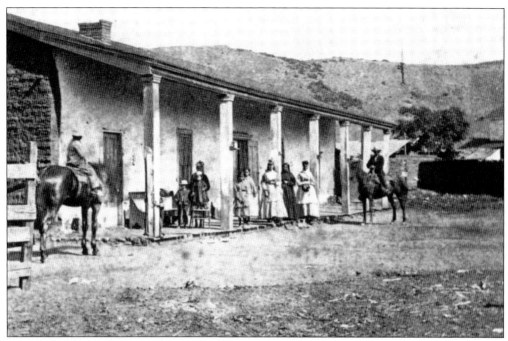

Marrón family members posed in front of Juan María Romualdo Marrón's *casa* in 1874. Most large rancheros had a home in Old Town as well as their ranch house. Marrón's 1853 will described this house as a "hall and two sleeping rooms, a backyard enclosed by adobes, and two interior rooms that serve as store rooms." The house was abandoned after Felipa died, and it gradually collapsed. (SDHS#80:2839.)

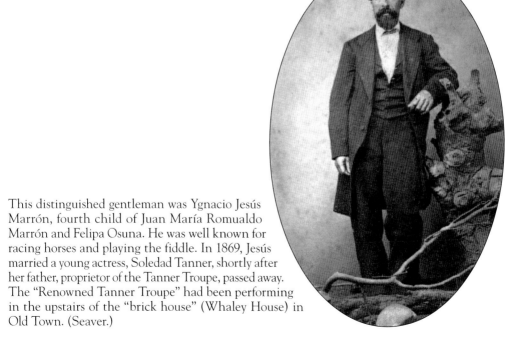

This distinguished gentleman was Ygnacio Jesús Marrón, fourth child of Juan María Romualdo Marrón and Felipa Osuna. He was well known for racing horses and playing the fiddle. In 1869, Jesús married a young actress, Soledad Tanner, shortly after her father, proprietor of the Tanner Troupe, passed away. The "Renowned Tanner Troupe" had been performing in the upstairs of the "brick house" (Whaley House) in Old Town. (Seaver.)

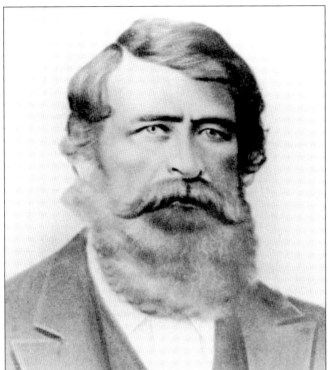

Like his older brother, who was also his godfather, Silvestre Marrón (1827–1906) married into the Osuna family of Rancho San Dieguito. While Juan María Romualdo was busy with San Diego politics, Silvestre managed the ranch. Juan María Romualdo willed Silvestre a portion of the ranch in the El Salto area, as well as grazing rights and salt gathering rights over the entire ranch. (SHC.)

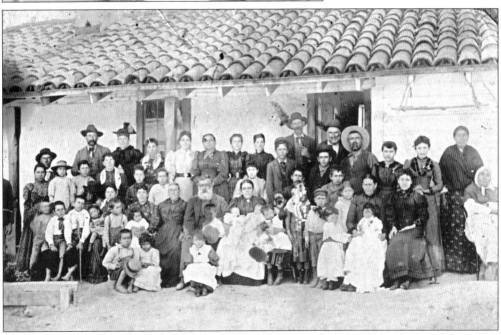

Family members and friends gathered at Silvestre Marrón's adobe in 1895. Seated in the center between his second wife, Pilar, and his daughter Felipa, Silvestre was surrounded by children and grandchildren. Felipa held her twin babies, Joseph and Mary, with her other children nearby. Silvestre's daughter María de la Anunciación stood behind him and son Juan María was in front of the door at the right. (SHC.)

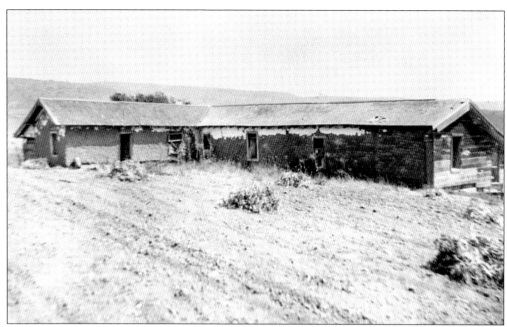

Silvestre Marrón inherited from his older brother that section of Rancho Agua Hedionda called "the planting lands of the Rinconada" along Buena Vista Creek. He was a farmer, rancher, and orchardist. Pears, grapes, pomegranates, oranges, and barley were grown. These photographs from the 1930s of Silvestre Marrón's adobe house show its basic two-wing L-shape. Silvestre's oldest daughter remembered a brick oven, or *horno*, for baking in the corner and a *pretil* for cooking. Built like a table, the *pretil* had holes and irons on top for the pots and pans. A calfskin was used for a door. Water was supplied from the nearby creek. The photograph below shows the same side of the house where the family group photograph, shown opposite, was taken in 1895. (Above, SDHS#9428; below, SDHS#9428-2.)

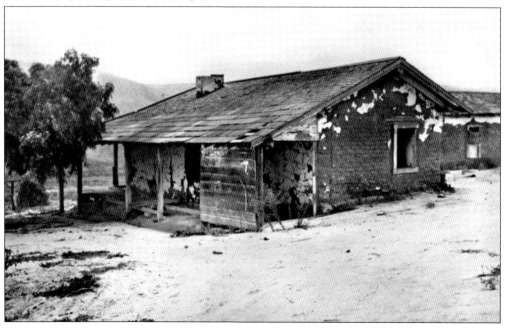

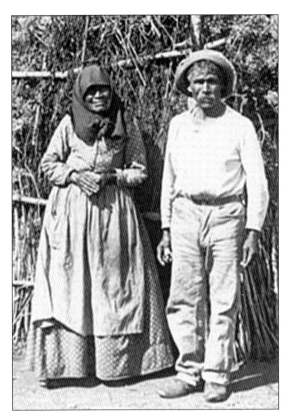

Refugio Ortiz and her husband, Honorato Garcia, lived on Rancho Agua Hedionda near Silvestre Marrón. As a mason, Honorato would have been in much demand on the ranchos. He was known as a "solid, intelligent, hard-working Sonoranian." His wife, Refugio, was born at Pala, where the couple and their family lived in later years. (SHC.)

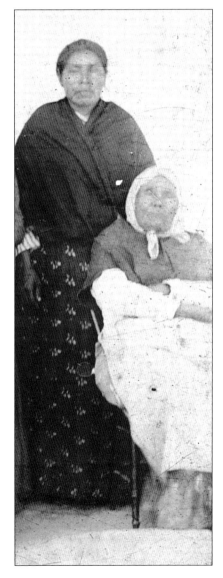

Local Native Americans helped the Marrón family in the house and in the fields. Some were considered members of the family, like these two women from the 1895 group photograph. Silvestre Marrón's daughter remembered a bandit coming to the house while the men were away. A Native American named Tomasa "came out to protect my mother who was crouched by the house with us children. Tomasa told the man there was no one at home." (SHC.)

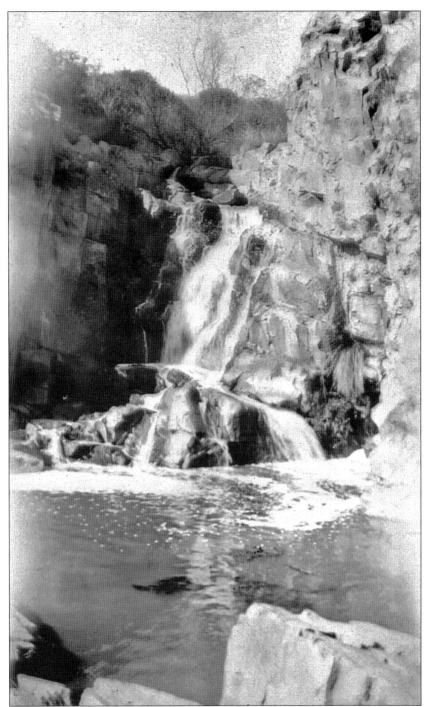

Located on Rancho Agua Hedionda within sight of Silvestre Marrón's adobe home, El Salto Falls on Buena Vista Creek sometimes dropped 40 feet. Mentioned in the early land grant documents and in Juan María Romualdo Marrón's will, El Salto was an important ranch landmark. In the early 1900s, the falls were a popular picnic spot. The local Luiseño Indians consider El Salto a sacred site. (SHC.)

Felipa Emerenciana Marrón (1857–1947) was the daughter of Silvestre Marrón and Leonora Osuna. Unlike her older siblings, who were born at Old Town, she was born in Marrón Canyon. Felipa married the enterprising John Chauncey Hayes in 1875 but continued to live on the ranch. The first seven of their 14 children were born in their adobe home near Silvestre's. All her children lived to adulthood. (SHC.)

John Chauncey Hayes (1853–1934) was born in Los Angeles and was educated at Santa Clara College. His father, Judge Benjamin Hayes, rode the circuit of Los Angeles, San Diego, and San Bernardino. They lived first in Los Angeles and later in San Diego. Chauncey wrote for the newspaper, clerked for his father, and had started his own land business by the time he married Felipa Marrón. (SHC.)

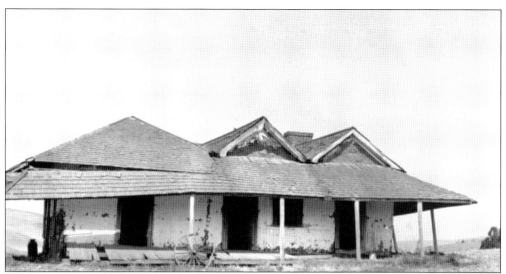

Felipa and Chauncey Hayes's adobe home was located just west of Silvestre's house. They lived there until they moved to South Oceanside about 1887. This one-story adobe had verandas on the outside. The unusual roofline suggests that the house was modified many times, perhaps to reflect the growing Hayes family's needs. (SDHS#OP17134-2453.)

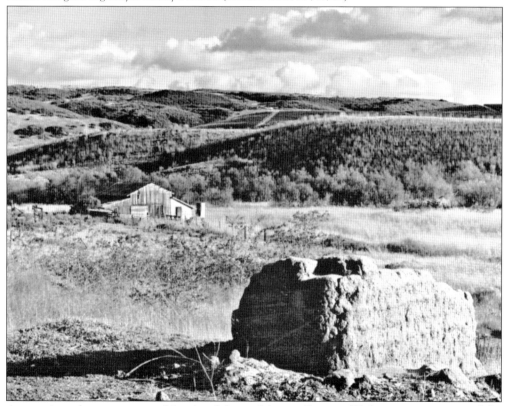

At one time, there were seven Marrón adobes in Marrón Canyon. Without maintenance, adobe houses "melt" back to the earth. This photograph shows all that was left of Felipa and Chauncey Hayes's house in 1977. The barn in the background was eventually torn down. (SHC.)

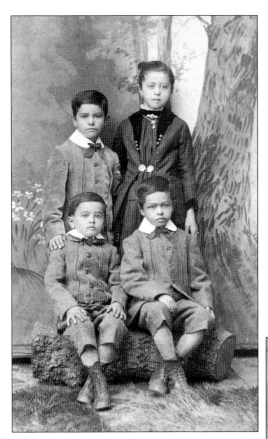

The four oldest children of Felipa and Chauncey Hayes were photographed about 1887. They were all born on the ranch. Sitting are Sylvester (left) and John Chauncey Hayes Jr. Standing are Benjamin and Emily. Both Emily and John Chauncey Jr. worked with their father in his real estate business. Emily married into the Argüello family. (Hayes.)

Fred Hayes, fifth child of Felipa and Chauncey Hayes, posed for this photograph about 1887. As an adult, Fred worked with his father in the Hayes Land Company in Oceanside. It was Fred Hayes who saw the value in preserving the Marrón ranch home where his grandfather lived, worked, and died, and where his mother was born. (Hayes.)

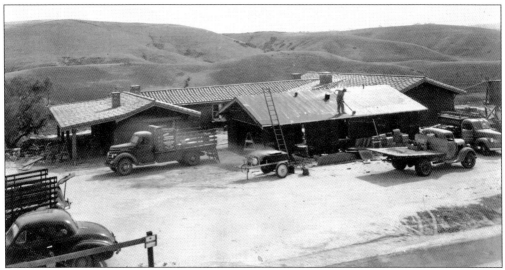

In 1947, Fred Hayes began the restoration of the two wings of Silvestre Marrón's adobe home and also added two wings to form a quadrangle. One of the new wings provided a grand *sala*, or living room, plus a kitchen and dining area. The fourth side was used as a garage and service area, including a water tower. (SHC.)

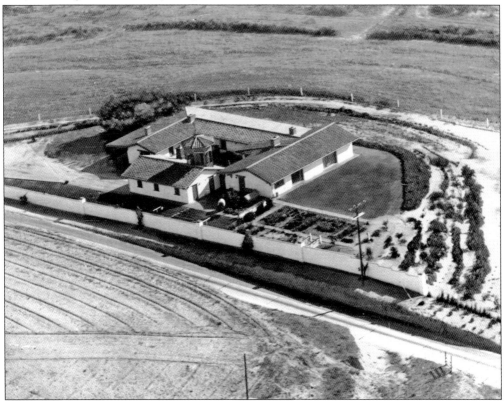

This 1949 aerial photograph of the completed Marrón family home shows its location along Vista Way. Fred Hayes, his wife, two sons, and their spouses, plus his grandchildren, lived there. Fred's granddaughter inherited the home of her grandfather and great-great-grandfather. (SHC.)

Judge Benjamin I. Hayes (1815–1877) came to California in 1849. Later he sent for his wife, Emily. As district court judge for many years, Hayes could speak and write Spanish fluently. He befriended many of the Californios and helped them with legal problems. Known as an expert on land issues, Hayes especially helped his son, Chauncey's, future father-in-law, Silvestre Marrón, defend his inheritance. (SHC.)

Portraits of Californio children are rare. This one portrays Silvestre Marrón's son Abran Lincoln Marrón (1864-1928), who was baptized at Rancho Peñasquitos. On either side of him, from the left, are his two nieces Leonora and Magdalena Pico. The girls are the children of his sister María de la Anunciación Marrón and Juan de la Cruz Pico of Rancho Santa Margarita. (VC.)

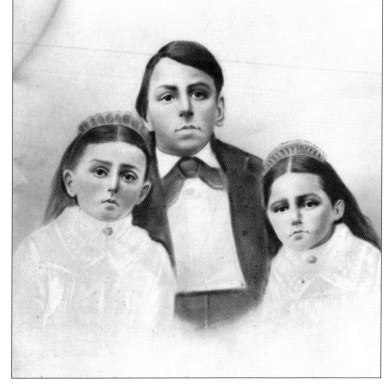

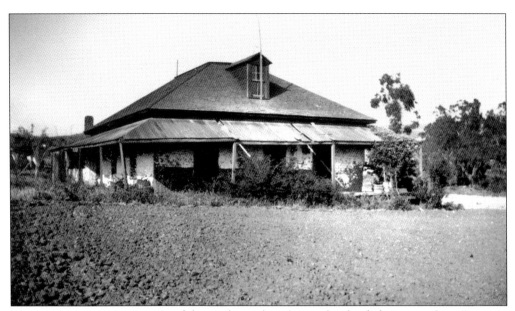

The Juan María Matías Marrón adobe was located on the north side of what is now State Route 78 in Oceanside. The home deteriorated and was torn down. Juan María Matías (1851–1924) was the oldest child of Silvestre Marrón. He married Lorenza Serrano (1855–1950) in 1875. Because so many family members lived in the area, it was called Marrón Canyon. (ABC.)

Adobe homes had thick walls, sometimes two feet thick. This 1937 photograph of the original Marrón ranch house shows a typical window from the adobe's interior. Adobe homes are cool in summer and warm in winter. In a land without a large amount of available lumber, they are a practical solution to housing needs. However, they do require regular maintenance. (LC.)

PUBLIC NOTICE.

THE UNDERSIGNED, JUDGES OF the Plains, notify all persons interested, that on Thursday, the 15th inst., the gathering of horse stock, will begin from the State boundary, and from the City of San Diego.

JOSE ANTONIO SERRANO.
SILVESTRE MARRON.

San Luis Rey, Cal., February 5th, 1872.

feb10td:w1.

Raising cattle was part of the Californio way of life, and huge herds roamed the ranches. Silvestre Marrón sometimes served as the Judge of the Plains to help organize and arbitrate the sorting out and branding of cattle, as the February 1872 public notice (above) indicates. In the diagram below, these cattle brands represent various members of the Marrón family who ran livestock on the Agua Hedionda. Note that brands were often registered to women and that brands were passed down through the generations. Shown in the top row, from left to right, are brands for José Marrón (1854); Juanito Marrón (1855), who passed it on to his brother Jesús Marrón (1861); and Felipa Osuna de Marrón (1855). Lower row brands are for Leonora Osuna de Marrón (1855), who passed it on to her son Abran Marrón (1887); and Juan María Matías Marrón (son of Silvestre, 1861).

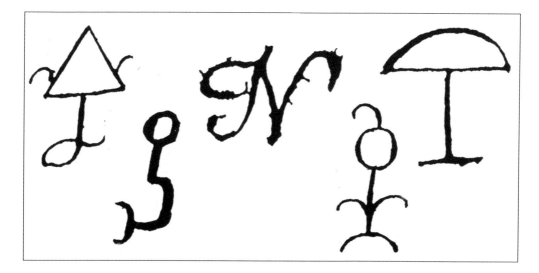

Five

RANCHO SANTA MARGARITA Y LAS FLORES

The largest of the San Diego land grant ranchos, Santa Margarita y Las Flores is familiar to San Diegans as the U.S. Marine Corps Base Camp Joseph H. Pendleton. The ranch covers the northwestern corner of San Diego County, extending from the coast inland to the town of Fallbrook, north to the San Clemente area, and south to Oceanside.

Spanish-era Rancho San Onofre y Santa Margarita belonged to Mission San Luis Rey. Cattle roamed the ranch. Wheat, corn, beans, and barley were grown. A house, garden, and vineyard were established. The western central part of this rancho was a Native American ranchería called Las Flores and a mission *estancia*, or station, called San Pedro, which served travelers.

With secularization of the missions, the huge land holdings were up for grabs. Rancho Santa Margarita was appraised at nearly $11,000 in 1835. Las Flores, not mentioned in the appraisal, was organized into a Native American *pueblo*.

Pío Pico, one of the appraisers, provisionally applied to Gov. Nicolás Gutiérrez in 1836 for land at San Onofre to secure his cattle, claiming that the Native Americans were stealing. The Native Americans resented Pico's use of mission lands.

In 1841, Pío and his brother Andrés applied to Gov. Juan Alvarado for a trade of their lands at Temecula for the lands at Santa Margarita—another move that displeased the Native Americans. The grant was completed for 12 leagues. The Picos added to their rancho by persuading the Native Americans to relinquish title to Las Flores in 1844.

The claim of the Picos for a clear title before the Land Commission was confirmed in 1855. Andrés Pico was forced to deed his half of the ranch to his brother in 1862 to satisfy creditors. The patent was issued in their name in 1879 for 133,440.78 acres.

When Pío Pico ran into financial difficulty, he sold Santa Margarita to his brother-in-law John Forster. The Forster family lived there until John and his wife died in 1882. Their heirs sold the mortgaged rancho to Richard O'Neill and James Flood. The O'Neill-Flood partnership ran the ranch until it was acquired by the U.S. Navy in 1942.

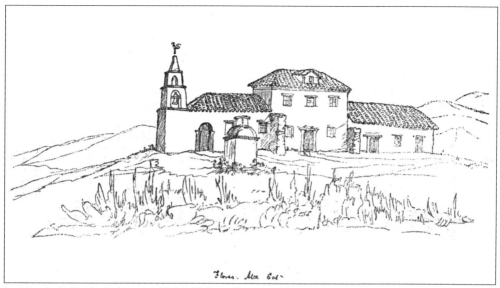

In March 1850, English artist H. M. T. Powell stopped by the estancia of Las Flores, mistakenly thinking it was a mission. His diary noted grass, clover, wild mustard, and beautiful flowers in profusion. He also spotted sandhill cranes. Now all that remains of this extensive tiled-roof complex is a solitary lump of melted adobe near the Las Flores ranch house.

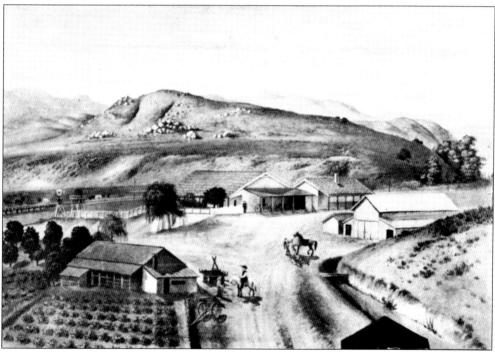

The Santa Margarita ranch house was the heart of the vast rancho. This unknown artist's sketch shows that area around 1875 with more improvements than during the Pico brothers' era. Pío and Andrés Pico probably built a small, two-room adobe home. Their brother-in-law John Forster repaired and expanded the dilapidated house, adding more outbuildings, corrals, and fencing. (USMC.)

70

As the last Mexican governor of California, Pío Pico (1801–1894) wielded much political power. Rancho Santa Margarita was a rich estate. He also provisionally acquired one league of Rancho Jamul. After its abandonment due to raids, he regranted two leagues at Jamul to himself in 1845. Pío and his wife, María Ygnacia Alvarado (1808–1854), occupied the Santa Margarita ranch until 1849. Family members and employees lived there until 1864. (SM.)

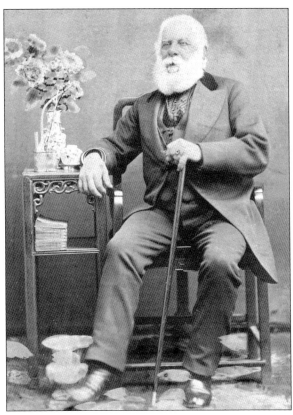

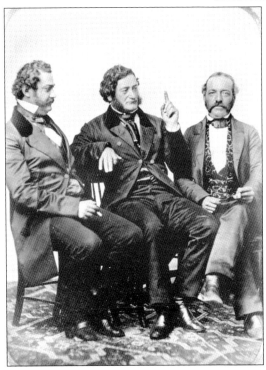

This photograph of three prominent Californios who made the transition into American politics shows (from left to right) Pablo de la Guerra, Salvador Vallejo, and Andrés Pico. Andrés Pico (1810–1894) lived in the San Mateo area of the ranch, where he had a house, garden, vineyard, and trees. Later he lived at ex–Mission San Fernando. Andrés Pico was the leader of the Californio forces at the Battle of San Pasqual in 1846. (Bancroft.)

María Ysidora Pico (1808–1882) married John Forster about 1837 after he was baptized in the Catholic faith. She came from a large, tight-knit family of mixed heritage that included her brothers Pío, Andrés, and José Antonio. Her father was a presidio soldier. They had a family home in San Diego, where her widowed mother did sewing to earn money. Ysidora passed away shortly after her husband's death. (USMC.)

Englishman John Forster (1814-1882) came to California with his uncle, who traded Chinese goods. He owned ranchos Trabuco, Mission Vieja, La Nación, and San Felipe. After living in San Juan Capistrano, he acquired the huge Rancho Santa Margarita in 1864 from his debt-ridden brother-in-law Pío Pico. Property title difficulties, including the rights of another Pico brother, José Antonio, led to litigation that was finally settled in Forster's favor.

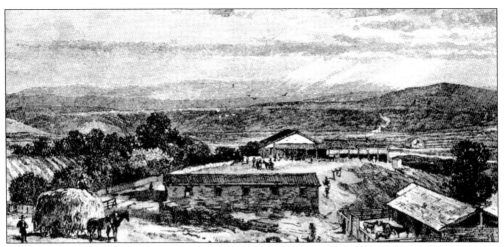

When Santa Margarita was transferred from Pico to Forster, the land had been experiencing a severe drought. Additionally, smallpox epidemics had hit southern California hard. John Forster had been able to run his four ranchos of more than 100,000 acres from Mission San Juan Capistrano. In 1865, when the mission was returned to the Catholic Church, he moved into Santa Margarita. This drawing of the ranch is *c.* 1882.

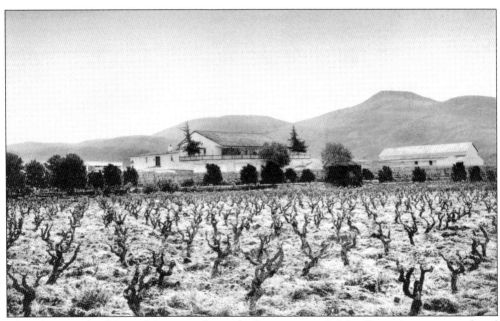

This photograph of Santa Margarita shows the large vineyard. John Forster's winery produced 1,200 gallons of wine in 1879. He marketed the wine in San Diego and San Francisco. Forster also had a wine cellar in his house. When this land belonged to Mission San Luis Rey, the padres had an extensive vineyard. An airfield is now located on the site.

Magdalena Baca (1823–1891) of New Mexico was the wife of José Antonio Pico, the oldest of the Pico brothers. They had their home on Santa Margarita in an area called the Pueblito. Her husband died in 1871 on the ranch, leaving her with a large family. She tried to bring a claim against the Forster holdings, but her claim was dismissed. (VC.)

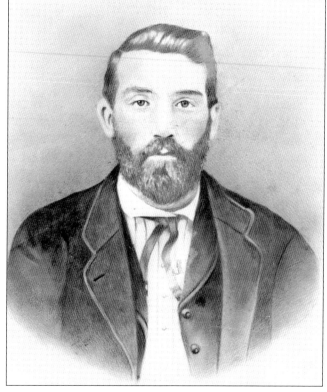

Juan de la Cruz Pico (1846–1875) was one of the sons of Magdalena Baca and José Antonio Pico. He married María de la Anunciación Marrón of Rancho Agua Hedionda. He died suddenly on the road between San Luis Rey and his residence, called El Estero, near Silvestre Marrón's. His widow, left with two young daughters, married his younger brother Andrés Pico. (VC.)

Crosses have been placed near the site of the main ranch home and the site of the Pueblito, home of José Antonio Pico and his family. His brother Pío testified that José Antonio came to the ranch in 1853 with his consent, living there until 1871. Previously, they lived in buildings at Mission San Luis Rey. (Baumgartner collection, USMC.)

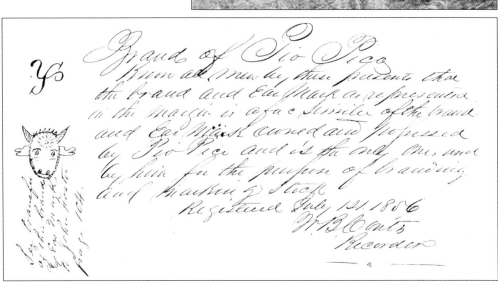

This entry from the first San Diego County Brand Book shows a brand belonging to Pío Pico. The brand was registered in 1856 and was transferred to John Forster in 1863. It may have been the brand that Pío referred to as "El Guiterrano." He also had a half moon brand that was registered in 1858. The heart brand belonged to his brother Andrés. These brands were used on Santa Margarita.

The U.S. Marine Corps restored this building, making it a chapel. Thought to be the oldest structure on the rancho, this building may have been part of Mission San Luis Rey's holdings— perhaps a winery. Later it housed Pío Pico and his family until the ranch house was built. It was used by John Forster as a winery. Later owners used it for tools and to house the blacksmith shop. (Baumgartner collection, USMC.)

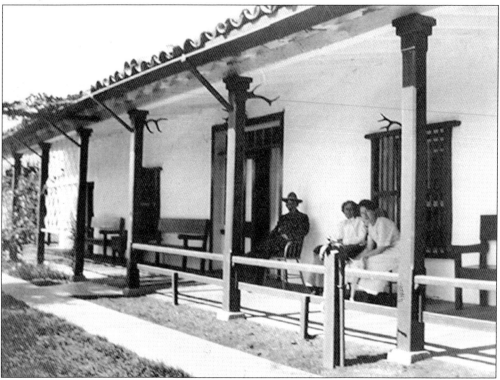

No passages connected the rooms at Rancho Santa Margarita. Entry was either from the veranda, patio, or hall. About 1916, walls were cut through. This photograph is from the Baumgartner family era. Note the deer antlers overhead. (Baumgartner collection, USMC.)

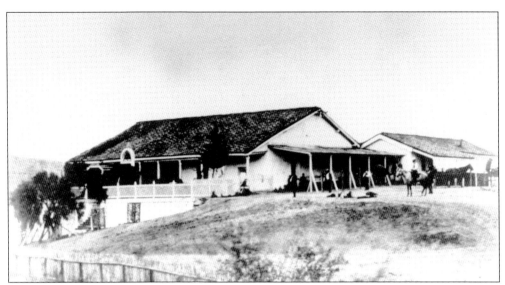

By the 1860s, John Forster found that hides and beef were no longer in big demand. After making extensive improvements to the ranch, he faced financial difficulties. The 1872 law requiring ranchers to fence their land added another huge expense. One plan, to colonize the ranch and develop Forster City, had limited success. The photograph shows the carriage lean-to on the southwest corner of the house. (Baumgartner collection, USMC.)

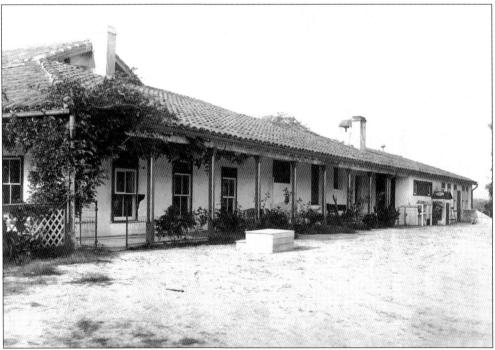

In 1882, after the deaths of John and Ysidora Forster, their sons were forced to sell the ranch. Their father had run the ranch as "monarch of all he surveyed" with a large staff of Native American and Mexican employees and vaqueros. He had transformed the simple Pico adobe into a graceful, open square around an inner courtyard. This photograph, around 1915, shows the south view of the house. (USMC.)

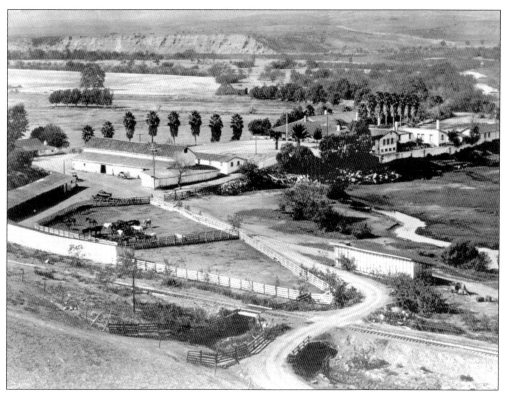

This 1917 photograph of the Rancho Santa Margarita complex shows railroad tracks on the south side of the ranch. Supplies became more readily available, and there was less of a need for self-sufficiency. John Forster's dream of a railroad was not realized until after his death. (USMC.)

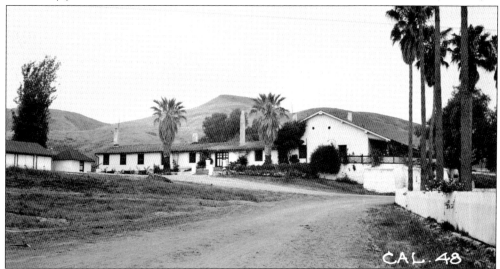

Each additional owner added to and modified the existing buildings. However, the Pico nucleus of the house remained as part of the structure. A major restoration project, including structural repairs to the ranch house and bunkhouse, was undertaken in 1916. This 1937 photograph, taken as part of the Historic American Buildings Survey (HABS), shows the northwest elevation of the house from the west. (LC.)

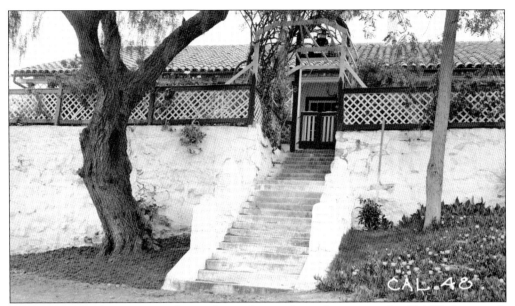

The staircase to the terrace on the southwest front is shown here in another HABS photograph from 1937. Alterations to the building in later years were made of concrete, hollow tile, and frame construction that was plastered and painted. (LC.)

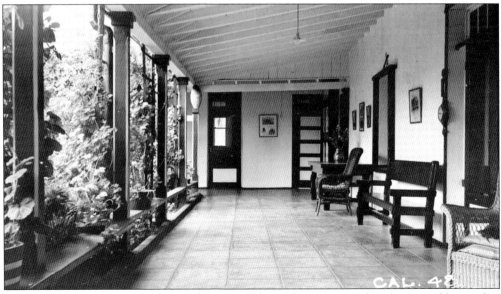

This 1937 photograph shows the southwest corridor of the patio. Outdoor living and hospitality were important factors in Californio homes. According to journalist Benjamin C. Truman, "His house was open at all hours, and stranger and friend fared sumptuously. . . The table was set three times a day and groaned from its weight. . . The Don sat at the head of the table, and Mrs. Forster at his right." (LC.)

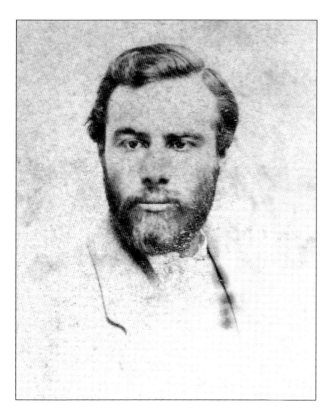

Francisco (Chico) Forster (1841–1881), son of John Forster and Ysidora Pico, served as a Judge of the Plains for the sorting and branding of cattle. In 1870, he and Miguel Pedrorena traveled with Gov. William Seward to Cuba, New York, and Mexico. A handsome bachelor, he was killed by a young woman in Los Angeles when he failed to marry her. (JJ.)

The oldest of three surviving children of the Forsters, Marcos Antonio Forster (1839–1904) started work on his Las Flores adobe in 1867, probably using some materials from the old estancia. Shown here with his wife, María Guadalupe Ávila (1839–1899), and two of their children, Marcos Forster was a magnificent horseman. After his parents died, the vast ranch was sold, and the family moved to San Juan Capistrano. (LAPL.)

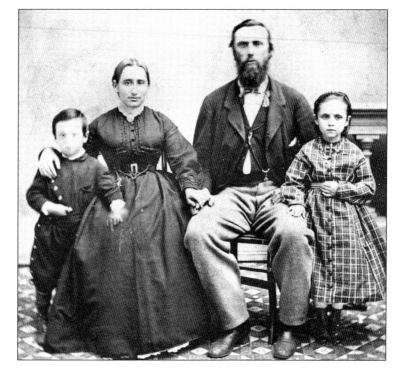

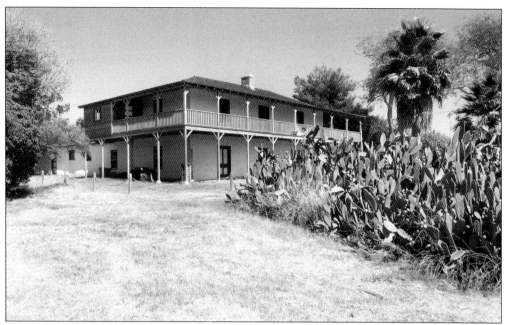

This two-story, Monterey-style adobe home of Marcos Antonio Forster at Las Flores combines elements of a traditional Spanish/Mexican adobe with New England framing. It was built among trees with an ocean view and served as a center of hospitality and a stage stop on the coastal Seeley and Wright Stage Line. Under later owners it was leased to the Magee family, who raised large fields of lima beans.

Restoration work on the Las Flores adobe began in 2001 by the University of Vermont with the support of the National Park Service and the U.S. Marine Corps. Stabilization and earthquake retrofitting, along with repairs for termite damage and the replacement of flooring and roof, are among the many improvements being done to this home on the National Register of Historic Places.

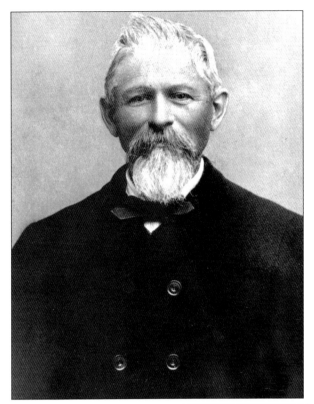

Richard O'Neill (1824–1910) purchased Rancho Santa Margarita y Las Flores in 1882 from the Forster sons. O'Neill was in partnership with James Flood, who put up most of the purchase money. O'Neill was in the wholesale meat business in San Francisco, where he first met Flood. O'Neill, working as ranch manager, and his family moved into the Santa Margarita ranch house. (USMC.)

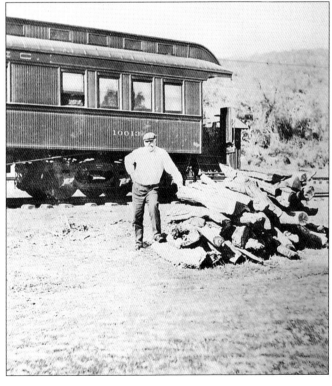

James C. Flood (1825–1889) was running a saloon in San Francisco when he met Richard O'Neill. Flood made a fortune in the Comstock Lode silver mines in Nevada. He was never concerned with the daily operations of the ranch. However, it was not until 1906 that his family deeded O'Neill his half ownership. Here Flood is seen with his private railroad car at the ranch. (USMC.)

Jerome O'Neill (1861–1926) had been running the Santa Margarita for his elderly father for a number of years when Richard died in 1910. As a bachelor, Jerome dedicated himself to operating the expanded ranch that, at the time, also included Forster's other ranchos, Trabuco and Mission Vieja, in Orange County. (USMC.)

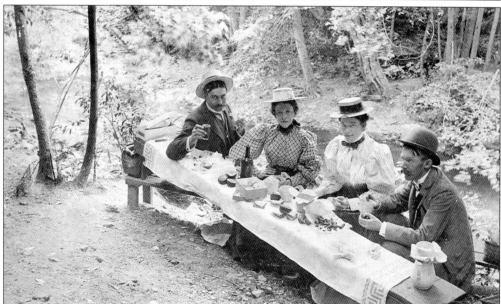

This 1897 picnic includes John Jay Baumgartner (1865–1946), far left, and Mary O'Neill Baumgartner (1871–1940), second from left. The other couple is unidentified. Mary was the youngest child of Richard O'Neill. When the expanded ranch holdings were finally split up in 1938, the O'Neills took the northern part of Trabuco, the Baumgartners took the middle (San Onofre), and the Floods took the southern part of Santa Margarita. (Baumgartner collection, USMC.)

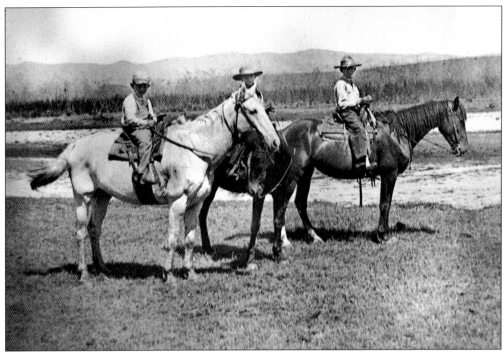

Grandsons of Richard O'Neill continue the family tradition of horseback riding and enjoying the ranch, about 1910. The sons of John Jay and Mary O'Neill Baumgartner are (from left to right) John Jay Jr., Jerome, and Richard. (Baumgartner collection, USMC.)

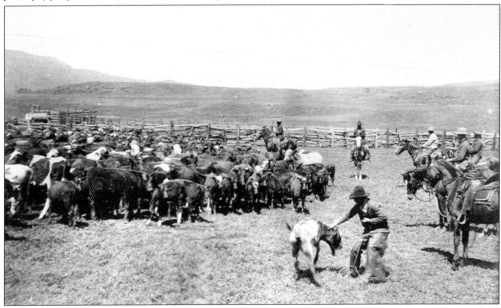

The ranch was the scene of periodic roundups, rodeos, exhibitions of vaquero skill, and hospitality. One 1873 reporter wrote, "Imagine five thousand cattle gathered together in a space of twenty acres, bellowing and fighting, with thirty or forty horsemen riding in among them, singling out their respective animals." The ranch continued to be a scene of cattle roundups under later owners, including this one during the O'Neill management. (Baumgartner collection, USMC.)

Six

RANCHO SAN DIEGUITO

Rancho San Dieguito, once owned by San Diego's first *alcalde*, or mayor, has become the wealthy community of Rancho Santa Fe, with elegant homes, rolling estates, gentleman farms, golf courses, horse farms, and a rural atmosphere.

Juan María Osuna (1785–1851) was granted one league of land at Rancho San Dieguito in 1840 or 1841 by Gov. Juan Alvarado. He received a one-league augmentation to that grant in 1845 by Gov. Pío Pico. Land grants were often given to retired soldiers and as political favors. Osuna had served as a *cabo*, or corporal with the San Diego Company. His father, Juan Ismerio Osuna, came overland to Alta California, with the 1769 expedition. When San Diego's size entitled it to rank as a *pueblo* (town) in 1835, Juan María Osuna was elected the first *alcalde*.

Provisional land grants were made to portions of San Dieguito prior to 1840. Retired soldier Juan María Cañedo was given permission in 1826 to settle there, graze cattle, and sow crops. Osuna and his family first settled there about 1828. According to historian Hubert Howe Bancroft, the Silvas family was given a provisional grant in 1831. Andrés Ybarra applied repeatedly for the adjacent Rancho Los Encinitos, sometimes applying jointly with Osuna for both ranchos.

When the mission system was broken up, some Native American neophytes from Mission San Diego were organized into pueblos. One of these pueblos was established at San Dieguito about 1833 with 15 families. By 1839, the Native Americans were complaining that their best lands had been taken away by Osuna, leaving them only salty soil. Another report the following year said that little remained of the pueblo, not even a corral. There were 11 families with 21 children.

At a meeting called in 1840 to settle ownership of Rancho San Dieguito, government officials met with Native American leaders, Osuna, Ybarra, and Cañedo. After that meeting, Rancho San Dieguito was confirmed to Juan María Osuna.

Osuna died in 1851, leaving his widow, María Juliana Lopez (1791–1871), to petition the Land Commission. The patent was issued in 1871 for 8,824 acres.

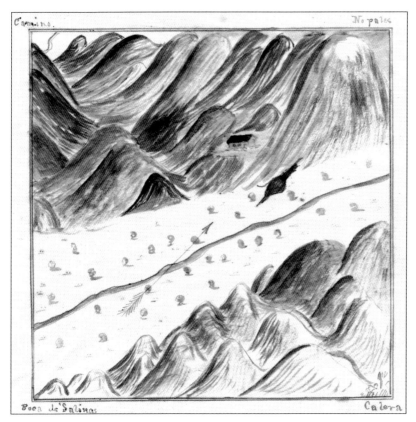

Hand-drawn maps, called *diseños*, were used to support land claims for the vast ranchos. This drawing of Rancho San Dieguito, signed by Santiago Argüello and dated January 24, 1850, was submitted by Juliana Lopez de Osuna. A directional arrow pointing north is located in the middle of the canyon. The house is shown above the canyon. (Bancroft.)

This is the signature of Juan María Osuna, including the flourish at the end called a rubric. Citizens of colonial Spain used a squiggly mark at the end of their name that was unique to them. It could be likened to a seal or a personal initial. Osuna, as the *alcalde* of San Diego, used this signature on official documents.

This elaborately decorated powder horn was carried at the Battle of San Pasqual by Leandro Inocencio Osuna (around 1817–1859). Leandro and several brothers, sons of Juan María Osuna, fought on the Californio side in this war between Mexico and the United States. Armed with a lance and pistol, he killed Capt. A. R. Johnston with his shot. Years later, suffering from depression, he committed suicide. (SDHS#86:15874.)

Francisca Marrón (1825–1914) married Leandro Osuna in 1840 and lived on Rancho San Dieguito. Their large family married into the well-known early California families of Pico, Alvarado, Zamarano, Estudillo, Argüello, and Crosthwaite. Francisca continued living on Rancho San Dieguito long after Leandro died. In later years, she resided on the ranch with her youngest son, Ramón, and his family. (VC.)

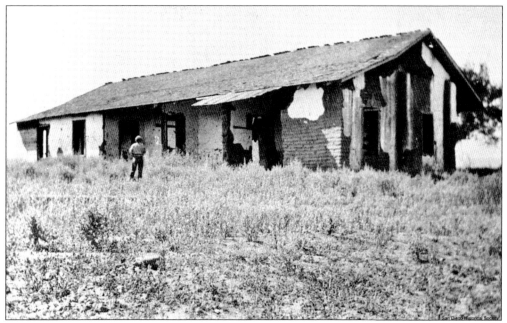

Considered to be the oldest Osuna adobe on Rancho Santa Fe, this dilapidated adobe was photographed in 1924 prior to restoration. Osuna's son Leandro probably lived in this adobe while tending the ranch for his father, who also had a home in San Diego. In 1850, Osuna was assessed for one home in San Diego and one on San Dieguito with its granaries and corrals. (SDHS#96:19534.)

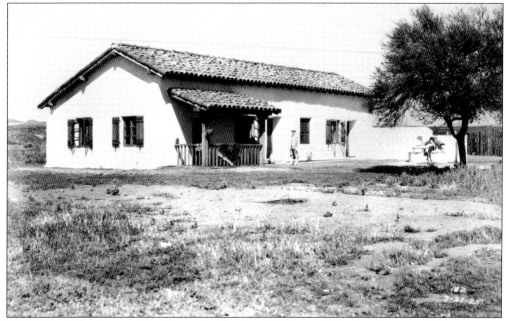

In 1906, little land was still in Osuna hands when the Santa Fe Railroad acquired this property. Then, in 1924, the house became the property of A. H. Barlow, who hired community architect Lilian Rice to restore and expand the adobe. She replaced the shingled roof with tile and added shutters, an interior fireplace, and an open kitchen. (LC.)

This second adobe was built by the Osunas sometime after the other adobe. It may have been lived in by Osuna's widow, Juliana. The Osunas had a family of 14 children, many of whom lived on the ranch with their families. Three of the children married into the Marrón family of Rancho Agua Hedionda, including Felipa, who married Juan María Romualdo Marrón, another political leader of San Diego. (LC.)

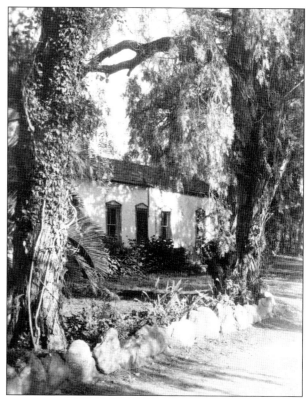

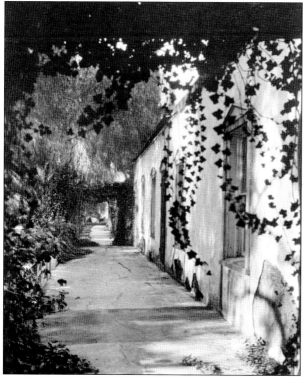

The most famous owner of the Osuna adobe was Hollywood singer Bing Crosby. He bought the property in 1932 and hired architect Lilian Rice to restore the old adobe to be used as a guest house and to build a larger adobe residence that complemented the original. (LC.)

89

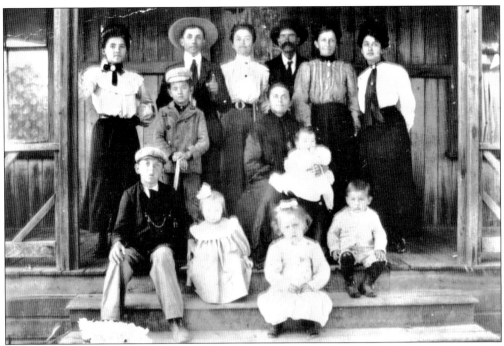

Descendants of Leandro Osuna and his wife, Francisca Marrón, posed around 1904. Sitting on the steps, from left to right, are Julio Osuna Jr., Bertha Smith, Elsie Bates, and Johnny Bates. Seated in the second row, holding a baby, is Josefa Crosthwaite Osuna, wife of Leandro's son Julio. Marcus Osuna is standing to Josefa's left. Also standing, from left to right, are Lucy Osuna, John Osuna, Lee Osuna, Frank Osuna, Mary Osuna, and Ruth Osuna. (SDHS#15647.)

In an act of stewardship and preservation, the Rancho Santa Fe Association purchased the oldest Osuna adobe and 28 acres of the horse farm in 2006. The association plans to keep the land as dedicated open space. Long-range plans for restoring the adobe and its surroundings to reflect its long history are being carefully evaluated.

Seven

RANCHOS SANTA MARÍA AND SANTA YSABEL

Ranchos Santa María and Santa Ysabel were located in beautiful inland valleys among lush grasslands and stately oaks. Santa María encompassed 17,709 acres, including most of the current community of Ramona. Santa Ysabel totaled 17,719 acres and covered the entire Santa Ysabel valley and mountains on either side. Prosperous and important Kumeyaay villages of Elcuanan and Pamo occupied areas of these ranchos for thousands of years before the Spanish arrived to establish a mission *asistencia* there. The Kumeyaay Indians continue to live in the area today.

Lorenzo Nelson Hartwell, a Boston sailor, applied for Rancho Santa Ysabel in 1839, claiming he had worked the land for eight years. His request was rejected because the land belonged to the church. José Joaquin Ortega and Capt. Edward Stokes were granted ownership of both ranchos in 1843 and 1844, mistakenly thinking the ranchos were connected. Ortega, whose grandfather came to California in 1769, settled in San Diego in 1821. Stokes was an English seaman married to Ortega's oldest daughter, María del Refugio. The Ortega-Stokes partnership stocked the land with cattle and sheep. However, Stokes died soon afterward, leaving his wife, Refugio, with three young sons.

After statehood, things became difficult for the Ortega-Stokes family. They sold Rancho Santa Ysabel in 1852 to Susan McKinstry. The McKinstrys used the ranch as a military supply depot. Antonio María Ortega, son of the original grantee, reacquired the ranch for his family following financial setbacks by the McKinstrys. Further changes ensued. Bernard Etcheverry acquired Santa María in 1880, and Alfred Henry Wilcox, an early Colorado River steamboat captain, purchased Santa Ysabel in 1868. Wilcox, who was married to María Antonia Argüello, had another rancho at La Punta on the road to Tijuana.

Parts of both ranchos have been cattle ranches for more than 165 years. Santa María became the town of Nuevo, later called Ramona, while Santa Ysabel remained rural ranch land. San Diego County eventually acquired property on both ranchos to save them as preserves. Visiting these preserves harkens back to the Ortega-Stokes rancho days.

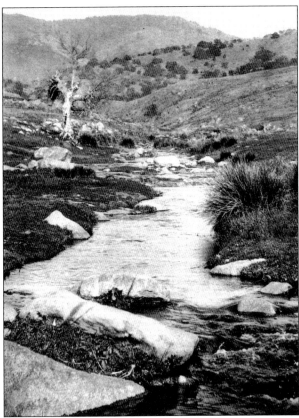

Santa Ysabel Creek, a tributary to the San Dieguito River, flows westward along Santa Ysabel Valley. In 1827, a mission padre reported that the Santa Ysabel Kumeyaay grew grapes for wine, and wheat, corn, beans, and vegetables in gardens. Sheep, goats, cattle, and horses covered the hills when the José Joaquin Ortega (1801–1865) and Edward Stokes families owned Santa Ysabel and Santa María.

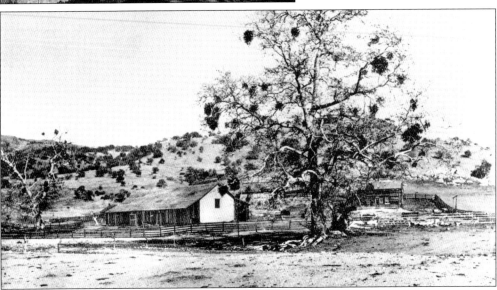

Edward Stokes (around 1805–1847) married Refugio Ortega (1823–after 1880) in 1842. They lived at Santa Ysabel, possibly in this adobe house, which no longer exists. Stokes was described in 1846 as wearing a black velvet English hunting coat and black velvet trousers cut off at the knee and open on the outside, beneath which were "drawers of spotless white." He also wore black buckskin leggings and six-inch spurs. (SDHS89:17761.)

An *asistencia* is a small-scale mission. The Santa Ysabel *asistencia* chapel is located near the traditional Kumeyaay village of Elcuanan. Served by padres from Mission San Diego, it was founded in 1818 after 230 Elcuanan residents had already been baptized. Over time, many different buildings served as the religious center for the tribe. This 1875 photograph shows an adobe chapel and bells. (SDHS#12108.)

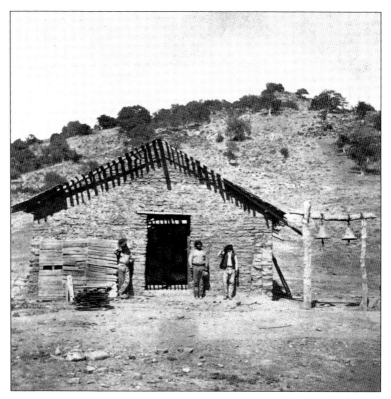

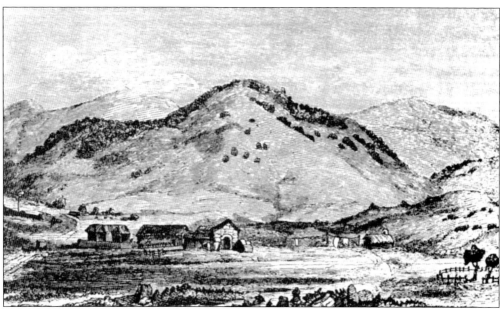

This 1855 woodcut of Santa Ysabel is the earliest known image of the area. This is probably how the area looked when Gen. S. W. Kearny and his army camped in December 1846. The Native American village was near the Stokes house. The chapel had been converted to a hall. A day earlier Edward Stokes offered to carry a letter to Commodore Stockton in San Diego announcing Kearny's arrival. (LC.)

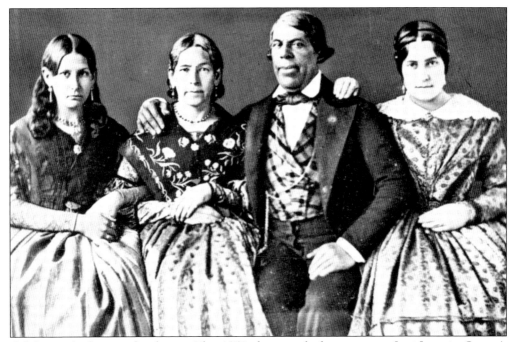

Californios had strong family ties. This 1850 photograph shows grantee José Joaquin Ortega's daughter María de la Trinidad on the far right. She is next to her uncle Pío Pico of Rancho Santa Margarita. Pictured with Governor Pico is his wife, María Ygnacia Alvarado, and their joint niece, far left, María de Jesús Alvarado of Rancho Peñasquitos. Both girls had Pico mothers. The Ortegas also had a house on Santa Margarita. (USMC.)

Joaquin Ortega Santa Ysabel
Santa Marías St Isabel Ranchos
38400 acres — $20,000.00
 House & Improvements 500.00
 1 yoke Oxen @ 50 300.00
 16 Tame Cows @ 20 320.00
 230 Wild Cattle @ 8 1840.00
 15 Tame Hrs @ 35 525.00
 154 Wild Mares Colts @ 7 1078.00
 15 Donkeys @ 10 150.00
 $ 2471.43
Antonia M. Ortega
 Poll Tax 3.00 Militia $2.00

This 1851 tax assessment shows that Joaquin Ortega owned both Santa María and Santa Ysabel for a total of 38,400 acres. As part of the Mexican government, Californios did not have to pay taxes, but as Americans, they did. This was a tremendous problem for the Californios because they were not used to using money. Many people lost their ranchos because they could not pay the taxes. (SDHS.)

Edward Ramón Stokes (1847–after 1930) was the youngest of three sons of Capt. Edward Stokes and Refugio Ortega. It is said that he looked the most like his father of all the sons. He was baptized at the Los Angeles Plaza Church with Andrés Pico and María Ygnacia Alvarado de Pico as godparents. Following his marriage, he moved to Santa Ynez to raise his large family, mostly girls. (JSC.)

Son of the rancho grantee, Adolfo Stokes (1843–1898), seated left, married his stepsister Dolores Olvera (1842–1897) seated right. They had six daughters and one son, Aristides. The Stokes daughters were, from left to right, (standing) Concepción (Connie), María Camila (Mary), and Flora; (seated) Esperanza (Hope), Hester, and Dolores (Dolly). Dolores brought sophistication to the rancho when she played her harp. (JSC.)

Emma Jane Libby Stokes (1876–1967) was a member of a pioneer dairy ranching family in San Luis Rey. Emma and Aristides were married on February 14, 1901, and raised five children. They first lived on Rancho Santa María and then moved to San Luis Rey in 1920. (JSC.)

Aristides Edward Stokes (1871–1944), son of Adolfo and grandson of Edward, was just a baby on Rancho Santa María when a newspaperman reported that the only occupants of the ranch were the families of the three sons of Capt. Edward Stokes. Aristides and his own family lived at the family ranch for 20 years. Stokes family members owned some rancho property into the 1970s. (JSC.)

This photograph, taken around 1904, shows three of the sons of Aristides and Emma Stokes. From left to right, the boys are Edward Clifton (1902–1981), Benjamin Franklin (1901–1975), and Charles (1903–1985). All three were born in their mother's San Luis Rey ancestral home. The boys and their younger brother and sister were raised at Rancho Santa María. (JSC.)

While he never lived in San Diego, Benjamin Minturn Hartshorne (1826–1900) was a business partner for the Colorado River steamship company with George A. Johnson and Alfred H. Wilcox. Hartshorne then joined Wilcox as owners of Rancho Santa Ysabel in 1869. Wilcox and Hartshorne had one of the largest flocks of sheep in San Diego and produced some of the best wool. (SM.)

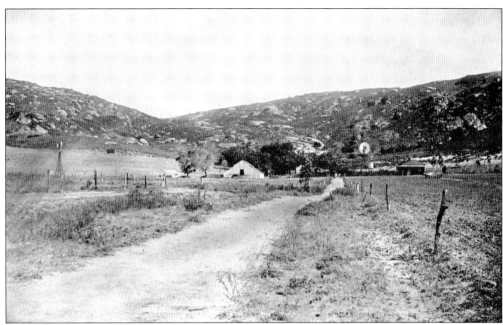

The Ortega-Stokes family used the beautiful valleys of Santa María and Santa Ysabel for cattle, horse, and sheep grazing. First known as Nuevo, the town of Ramona, which is part of Rancho Santa María, is named after the 1884 Helen Hunt Jackson novel *Ramona*. This is an early Stokes family photograph of their ranch east of Ramona, where the restored ranch house still stands. (JSC.)

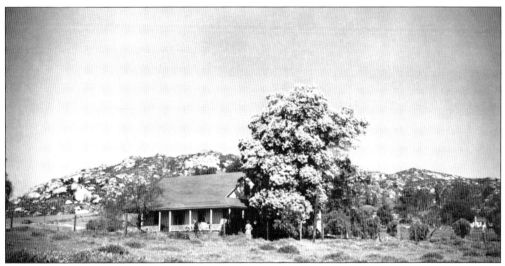

This ranch house was built in the 1870s by Adolfo Stokes, son of Edward and Refugio and grandson of José Joaquin Ortega and his wife, María Casimira Pico (1804–after 1883). In later years, Adolfo lived in Los Angeles with his mother; his stepfather, Agustín Olvera; and their combined families. Eventually, he returned home, where he ran a stage line between San Diego and the Julian mines. (SDHS#13373.)

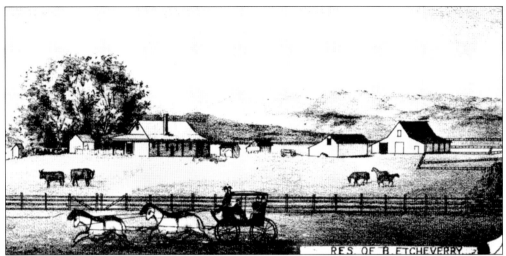

This 1883 drawing shows Rancho Santa María. By 1880, Basque Frenchman Bernard Etcheverry (1836–1912) owned Santa María, having bought out his partner Juan Arrambide. In 1881, he ran 12,000 sheep, some of his own and some belonging to the Ortega-Stokes family. The rancho also supported many orchards, vineyards, and barley and wheat fields. He encouraged modern, progressive farming operations with the sharecroppers who set up farms on his rancho. (RCM.)

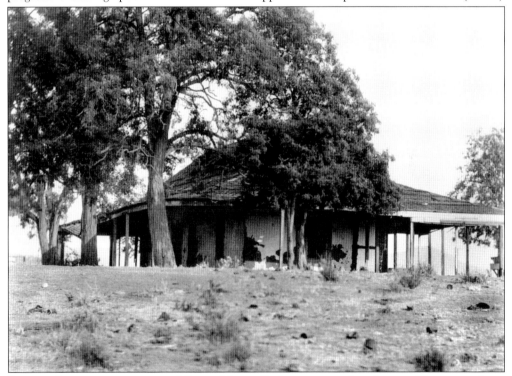

During the prosperous years of Santa María, Etcheverry employed up to 50 men to shear his sheep. In 1883, the wool production was 75,000 pounds. The following year, he sent five shiploads of sheep to market in San Francisco. Santa María was also known as having the finest vineyard soil in Southern California. This elegant Etcheverry ranch house was torn down in 1934. (SDHS#OP12423-1536.)

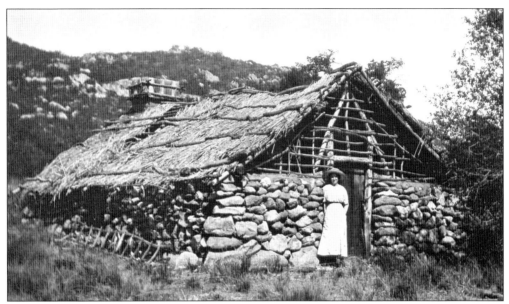

This 1910 photograph shows a rock-walled, thatched-roofed Kumeyaay home at Santa Ysabel. The woman is a tourist. Tourism is still a major business at both Ranchos Santa María and Santa Ysabel. (CW.)

To travel from Julian to San Diego by horse and carriage was rough, over roads that were just trails. Santa Ysabel was originally a major transportation corridor for the Kumeyaay, early immigrants coming from Sonora, the army traveling from San Diego, the first transcontinental mail, and for gold seekers headed to Julian. This 1910 photograph of Santa Ysabel Creek shows the usual transportation method. (CW.)

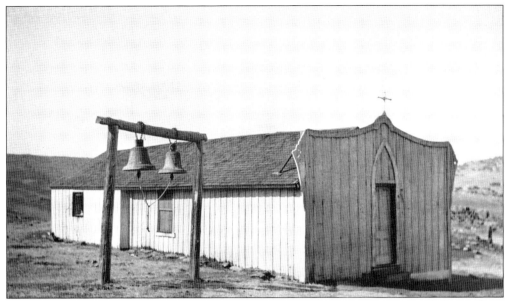

The Santa Ysabel bells have their own fascinating history. One of the original bells, made in 1723, came from the Loreto Mission in Baja California. The other dates to 1767. Both bells were stolen in 1926. The clappers were left behind and safely held by a local family. They were returned in 1959, but the bells themselves have never been found. This 1910 photograph shows the bells next to a wooden chapel. (CW.)

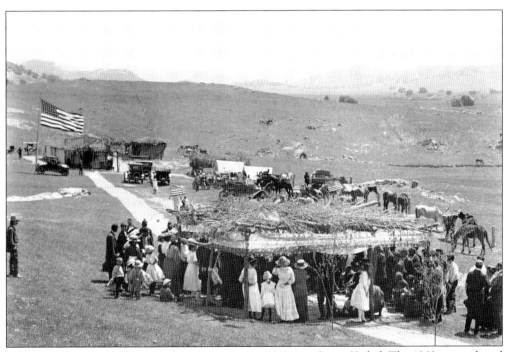

This 1914 photograph shows a religious ceremony at Mission Santa Ysabel. The 1860 census listed 185 Kumeyaay living in 30 houses at Santa Ysabel. Six of these people were said to be 100 years or older. (SDHS#4464-1)

In late 1878, C. R. Wellington wrote ranch owner Alfred H. Wilcox, requesting permission to build a small store on the road, just at the entrance to the Santa Ysabel Valley. Visitors can shop in it today. The house to the right was once the Hotel Santa Ysabel. Rooms cost 50¢ per night, and meals were an additional 50¢. A 1916 hotel advertisement noted "Good Home Cooking." (CW.)

Blacksmiths were an important part of Santa Ysabel in 1910, when this picture was taken. Blacksmiths worked by heating pieces of iron or steel in a forge until the metal became soft enough to be shaped with a hammer and chisel into nails, chains, horseshoes, shovels, and other tools. (CW.)

Eight

RANCHOS
VALLE DE SAN JOSÉ AND
SAN JOSÉ DEL VALLE

The broad, flat San José Valley is located in the mountains in northeastern San Diego County. Rancho San José del Valle and Rancho Valle de San José are better known as the Warner Ranch.

Silvestre de la Portilla received a grant of 17,634 acres in 1836 for the southern part of the valley (Rancho Valle de San José), and in 1840, José Antonio Pico received a grant for the 26,689-acre northern half (Rancho San José del Valle). Both tracts were abandoned by 1844 and granted to Jonathan Trumbull Warner.

By receiving this huge land grant, Warner joined the ranchero aristocracy that had developed in California. Warner established a trading post that carried flour, liquor, arms, and ammunition for weary travelers. He brought cattle from the Santa Margarita Rancho to supply fresh beef. Warner's prosperous trading post came to an abrupt end in 1851 as the result of a Native American uprising.

The San José Valley is in a unique location at the intersection of natural corridors from the desert to the coast. The area became an important overland migration and stage route. People had easy access to San Diego or Los Angeles. The valley was a major stopping place for 50 years (1830–1880), and the ranch house was built to accommodate weary travelers.

Vicenta Sepúlveda de Yorba y Carrillo was the next ranch owner. Tens of thousands of people took the southern route to the goldfields, passing by Warner-Carrillo. Vicenta built the existing ranch house, lived at the ranch longer than Jonathan Warner (1858–1868), and owned and managed the ranch during the Butterfield stage period of high activity. Yet for years, her name has not been associated with this building or the ranch. Warner's name is listed on all maps and in all historic accounts.

Cattle ranching continues in San José Valley as it has for more than 150 years. The land is owned by the Vista Irrigation District as a watershed. Cattle roam the hillsides just as they did during the Warner and Carrillo years.

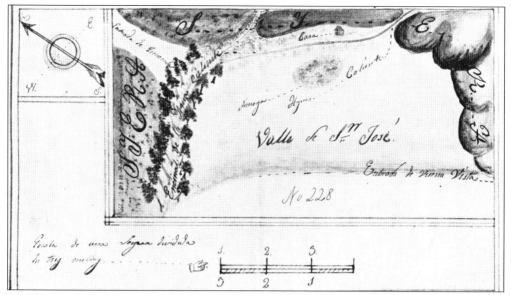

José Antonio Pico (1794–1871) submitted this *diseño*, or map, for Agua Caliente, later called San José del Valle. The rancho was granted in 1840. This map, drawn by Pico, shows portions of both the north and south land grants. (Bancroft.)

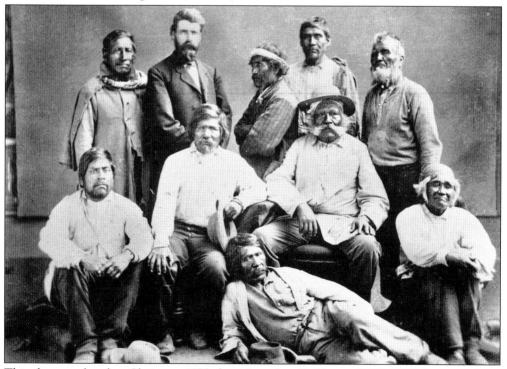

This photograph, taken Christmas 1875, shows Jonathan T. Warner (1807–1895), known as Juan José Warner, with a group of Native American vaqueros, most likely local Cupeños. Warner, who came to California in 1831, married Anita Gale (c. 1818–1859), who had been raised in the Jose María Pico family. Knowing that the Portilla and Pico ranches had been abandoned, Warner applied for a grant to the entire valley in 1844. (CHS collection, USC.)

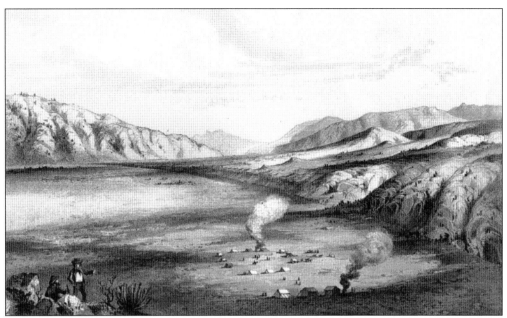

Jonathan Warner built an adobe house and trading post four miles south of the Agua Caliente hot springs, where the Native Americans were living. Warner's ranch was well situated at the desert's edge. Gen. Stephen Kearny and his army came through there in 1846, as did subsequent military and gold-seeking travelers coming to California by the southern route. This 1855 railroad survey lithograph shows Warner Pass from San Felipe.

When forty-niner Benjamin Hayes reached Warner Ranch, he wrote in his diary that the Native American homes were of adobe, some 25 feet long. The captain had a large corral formed by a high adobe wall. The Cupeño lived in the area until they were forcibly removed to Pala in 1903. Many of the Native American adobes still exist as part of the resort complex of the Warner Springs Ranch.

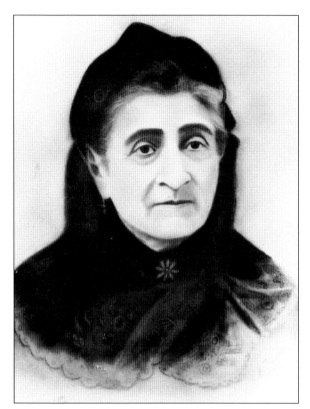

In 1858, Silvestre de la Portilla sold Valle de San José to the capable Vicenta Sepúlveda (1813–1907) on the condition that he could continue to live there. Vicenta, the widow of Tomás Antonio Yorba, had married José Ramón Carrillo in 1847. They moved onto the ranch, also known as Buena Vista. Ownership titles were confusing, and both Vicenta and Warner submitted claims before the Land Commission for overlapping land. (Anaheim.)

José Ramón Carrillo (1821–1864) was Vicenta's second husband. Legends would be written about him. Known for his bear fighting, horse riding, and racing skills, Ramón took part in skirmishes during the Bear Flag Revolt and fought at the Battle of San Pasqual. At Buena Vista, he was awarded the position of postmaster, but the official name was labeled Warners. He was murdered after being suspected of committing a murder. (Anaheim.)

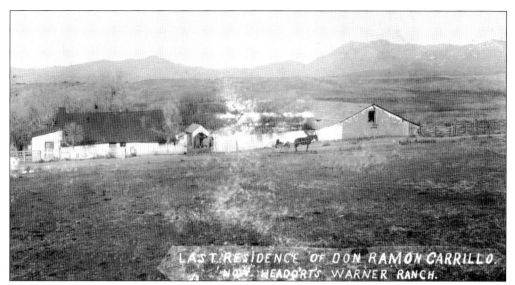

This rare photograph of the Warner-Carrillo ranch headquarters, taken around 1869 by an Anaheim photographer, shows the house, the large barn, and a structure between the two. Although scratched, the photograph gives a glimpse of what the ranch was like when Vicenta ran sheep in the valley and operated a stage station. (MCW.)

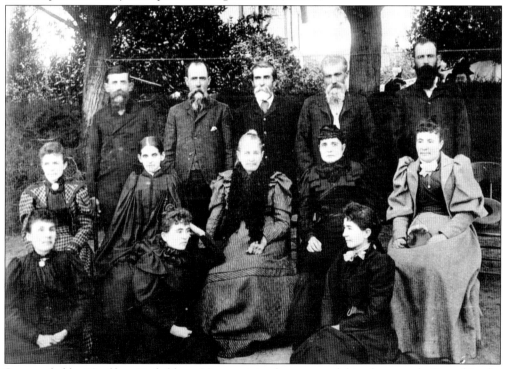

Surrounded by 12 of her 14 children, Vicenta is in the center of this photograph. Seated in the first row, from left to right, are Josefa Yorba, Natalia Carrillo, and Felicidad Carrillo. In the second row are Ygnacia Carrillo, Encarnación Carrillo, mother Vicenta, Edelfrida Carrillo, and Ramona Yorba. In the third row are her sons Cloromiro Carrillo, Ramón Carrillo, Antonio Yorba, Juan Yorba, and Garibaldo Carrillo. (Anaheim.)

This isolated ranch in San José Valley employed hundreds of Native Americans from nearby villages, including Cupa. One winter, during a smallpox epidemic, Vicenta ran a hospital at her ranch where she cared for the seriously ill Cupeños. This photograph of Cupa was taken about 1910. (CW.)

Vicenta Sepúlveda de Carrillo moved her family to Anaheim in 1869, selling one league of the Warner Ranch, including the ranch house, to ex–California governor John Gately Downey (1827–1894). Downey eventually added the remainder of the ranch to his holdings. Living in Los Angeles, he ran sheep on the ranch with the help of overseers. The wool from the Warner Ranch was noted for its large quantity and fine quality. (CHS collection, USC.)

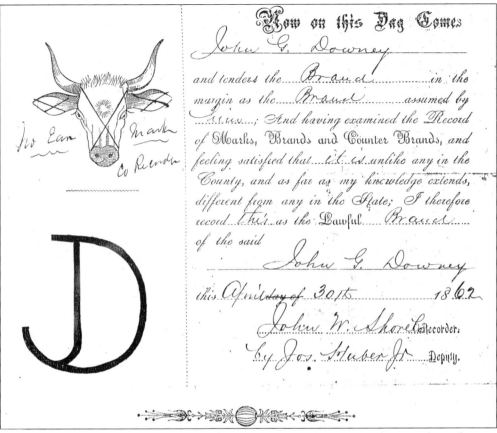

In 1862, John Downey registered this "D" brand in Los Angeles County after completing his two years as California's governor. Living in Los Angeles, Downey visited the ranch often in the 1870s and 1880s, sometimes supervising the wool clip himself. Besides sheep, his ranch had horses and other livestock. (SDHS.)

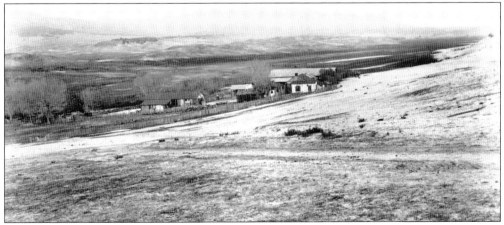

In 1888, John Downey began leasing the ranch to Walter Vail and other cattlemen. This early photograph of the Warner Ranch was taken in 1894, around the time that John Downey died. Downey's estate was tied up in litigation for a number of years and was finally settled in 1901. (SDHS#FEP879.)

This photograph of the Warner-Carrillo ranch house was taken for the Historic American Building Survey (HABS) in 1996. Originally, a HABS study was done in 1960. A great deal of deterioration, mostly from benign neglect, has been documented. The Vista Irrigation District, which owns the property, is working to find a way to protect this significant cultural resource. (LC.)

The question of who built this structure is unresolved. Warner's two-room adobe trading post was burned by Native Americans in late 1851. Whether the Carrillos added to the Warner ruins or built a separate adobe is unclear. Diaries and surveys do not clarify the issue. There is burn evidence to the two-room core of the building that makes it possible for this building to be both. (LC.)

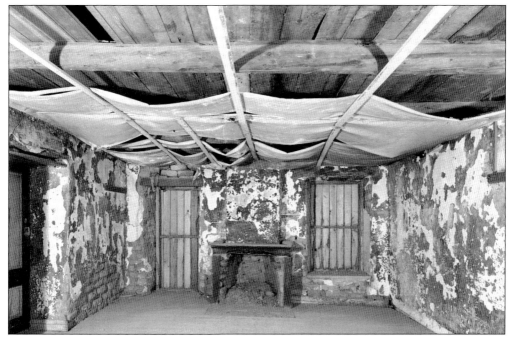

The ranch house is rectangular with a covered veranda. The original two-room structure has additions to the north and south, with three rooms in each. The additions were probably constructed by the Carrillos. Overhead, manta sheeting was used to keep dirt from falling from the ceiling. (LC.)

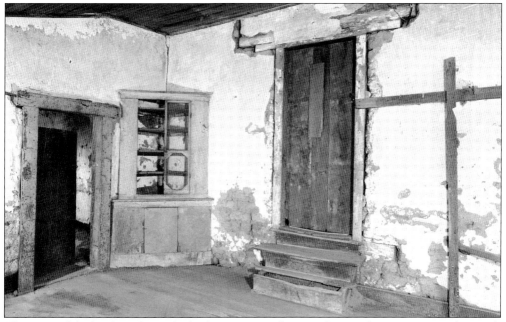

This view of the kitchen shows the built-in corner cabinet, a door to the east room in the north addition (left), and a door to the west room in the original two-room structure (right). There is also a built-in cabinet in the living room. The wood floor near the living room fireplace is scarred with a series of cattle brands. (LC.)

The barn at the Warner Ranch was probably built to its present appearance after the Downey sheep ranch period. Cattlemen like Vail would have needed a large barn to store hay and feed. The wood barn is peg-framed, probably dating from 1888, when large-scale cattle operations began. (LC.)

Recent structure reports have concluded that the ruined adobe walls on the western portion of the barn may have been part of the Butterfield stage station open-air corral. The adobes were probably formed with Cupeño labor. With building materials in short supply, succeeding builders would have made use of the existing structure to construct the barn. (LC.)

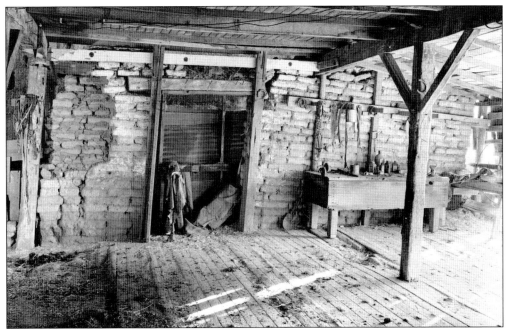

The barn is in extremely poor condition. Large sections have deteriorated due to neglect and harsh weather. Winds, rain, and snow contribute to the decay. The interior has a center aisle and two side aisles. There is also a lean-to addition on the east side, extending the length of the barn. (LC.)

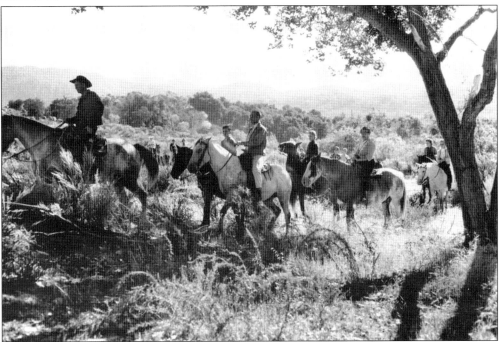

Cattle have roamed the San José Valley ever since the Californios owned the land. Besides Walter Vail, another well-known cattleman who used the land was George Sawday. This photograph is from 1972, but cattle can still be seen grazing on the gentle slopes of the Warner Ranch.

In 1961, the National Park Service nominated the Warner Ranch House as a National Historic Landmark for its "exceptional historic and archaeological value." The following year, about 150 people attended a ceremony for its dedication as a national landmark. A plaque was placed on the site. It was also designated as California State Registered Landmark No. 311. A San Diego County plaque marker was also installed.

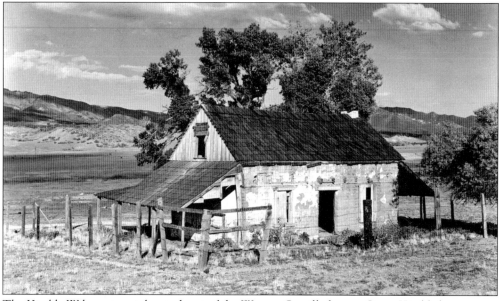

The Kimble-Wilson store is located east of the Warner-Carrillo house. Cyrus Kimble kept a store there, built around 1862. He called the area Kimbleville. His clerk was murdered in the store in 1865, and Kimble was killed on the road to Los Angeles a few months later. Henry Wilson took over the store in 1866. The building was used as a meeting place, stable, post office, and schoolhouse. (LC.)

Nine

RANCHOS LA PUNTA AND TIJUAN

The Argüello family's ownership of Rancho La Punta (Melijó) and Rancho Tijuan exemplifies the Califomio's strong commitment to family and the land. These two ranchos in southern San Diego were awarded to the Argüellos by Mexican governors but were subsequently lost. Some family members continued to live on small remnants of the original ranchos. Initially, both covered large acreages along rivers where thousands of head of cattle grazed.

Tijuan is a Kumeyaay word that probably means "by the sea." Mission San Diego records mention a Native American village of that name as early as 1809. Similarly, Melijó was also a Kumeyaay village name.

Rancho Tijuan, spanning two and a half leagues, was provisionally awarded to Santiago Argüello in 1829. In 1846, Gov. Pío Pico renewed the Tijuan grant for six leagues. The grant covered much of what is now the city of Tijuana and included land on both sides of the international border.

A former soldier and presidio comandante, Santiago Argüello held a variety of political offices in Los Angeles and San Diego. He married María del Pilar Ortega. He was also appointed administrator of the ex–Mission San Diego in 1846 in payment for services rendered. These ex-mission lands were awarded to him by the Land Commission in 1876 after his death. His widow, Pilar, tried to keep the Tijuan ranch in family hands. Litigation over it was extensive, with son Ygnacio taking the southern half and the other descendants claiming what was left of the northern.

Santiago E. Argüello, was awarded Rancho La Punta (Melijó) in 1833, which consisted of 4,439 acres. When he petitioned for the rancho, Santiago E. Argüello wrote that he wanted to be adjacent to his father's ranch. The rancho was located at the mouth of the Otay River. Shortly thereafter, he married María Guadalupe Estudillo. This rancho was not awarded to the Argüello family by the Land Commission, in part because of confusion over size. Guadalupe fought for many years to recover her family's ancestral land but was unsuccessful.

Today portions of both ranchos are included in large, open-space preserves.

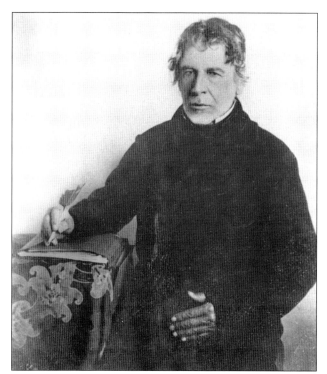

Santiago Argüello (1782–1862) and his wife, María del Pilar Ortega (1794–1879), wanted to use their Rancho Tijuan, but it was abandoned many times because of Native American raids. Eventually, he moved his family there. When two young girls were kidnapped from Rancho Jamul, Argüello was able to mount a group of men to follow the kidnappers. They were unsuccessful in getting the girls back. (SDHS#80:4571.)

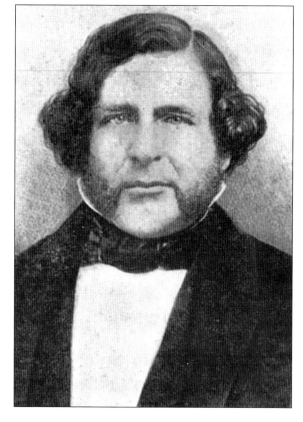

Santiago E. Argüello (1813–1857), oldest son of Santiago Argüello, married María Guadalupe Estudillo (1812–1889) of San Diego. They had seven children. During the Mexican-American War, he supported the Americans. Perhaps because his mother could read and write, he felt it important for all his children to be educated. He had a tutor brought into the home to teach the girls reading and writing, and even hired an English tutor.

For years, the Argüello home at La Punta was the nearest neighbor to San Diego. In 1849, when the border between the United States and Mexico was surveyed, William Emory of the topographical engineers made La Punta his headquarters and named it Fort Riley. Known for their hospitality, the Argüellos welcomed travelers into their large hilltop home near the road into Baja California and on stage lines. (SDHS#9415-2.)

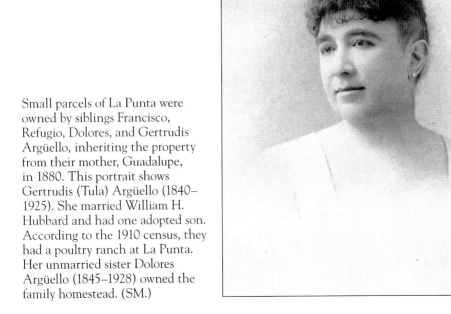

Small parcels of La Punta were owned by siblings Francisco, Refugio, Dolores, and Gertrudis Argüello, inheriting the property from their mother, Guadalupe, in 1880. This portrait shows Gertrudis (Tula) Argüello (1840–1925). She married William H. Hubbard and had one adopted son. According to the 1910 census, they had a poultry ranch at La Punta. Her unmarried sister Dolores Argüello (1845–1928) owned the family homestead. (SM.)

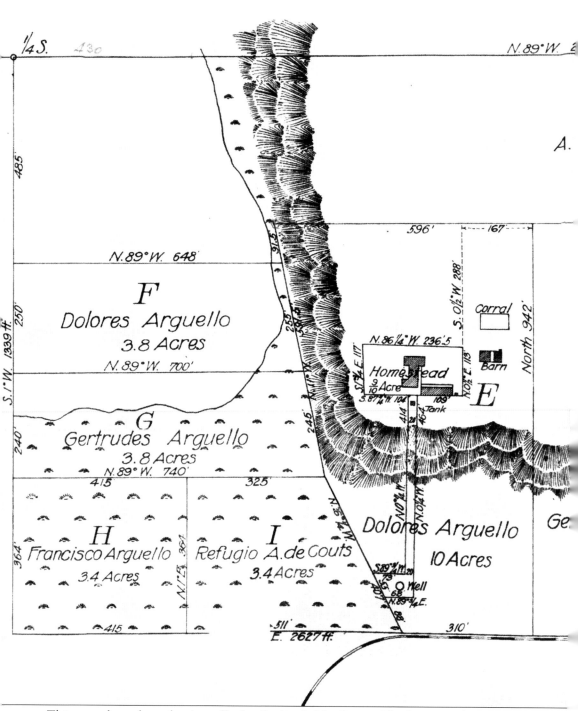

This map shows how the Argüello family divided La Punta. The homestead sat on a bluff overlooking the Otay River Valley. A. B. Hotchkiss was the lawyer who worked with the adult children of Santiago E. Argüello to retain some of the ancestral land. His payment in 1883 was

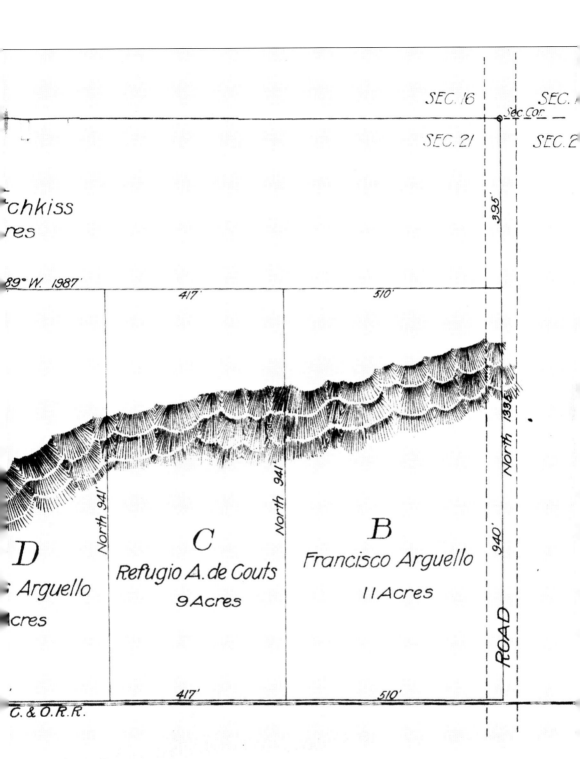

SEC. 16

SEC. 21

SEC. /

SEC. 2

Sec Cor.

395'

chkiss
res

89° W. 1987'

417'

510'

North 1335'

North 941'

North 941'

940'

D

Arguello

cres

C

Refugio A. de Couts

9 Acres

B

Francisco Arguello

11 Acres

ROAD

417'

510'

C. & O. R. R.

one-third of the 80 acres. María Antonia Argüello de Wilcox and her husband sold their holdings years earlier to the Honorable Zachary Montgomery, whose family pioneered flying.

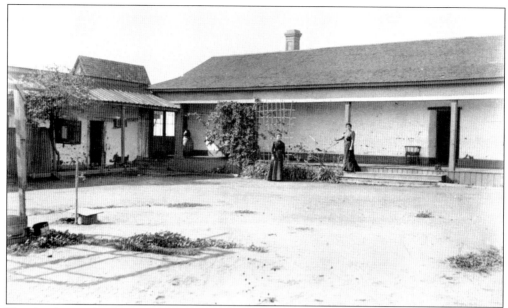

Two daughters of Refugio Argüello de Couts (1842–1926) are shown in the La Punta courtyard. Refugio divorced her husband, W. Blount Couts, brother of Cave Couts of Guajome, in 1879 and returned to her parents' home with her children. Oldest daughter, Catalina, on the left, was married at the old Argüello homestead to Josiah Shaffer, proprietor of the La Punta Salt Works. María Antonia Couts is also pictured. (SDHS#9415-3.)

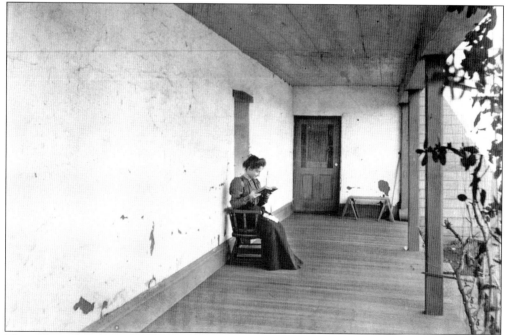

Throughout the 1870s, La Punta served as a destination for picnics and day outings for many of the people of San Diego. Advertisements promised meals at all hours, and occasionally, bands would play for entertainment at La Punta Gardens. Reading on the veranda is María Antonia Couts, granddaughter of Santiago E. Argüello. (SDHS#9415-4.)

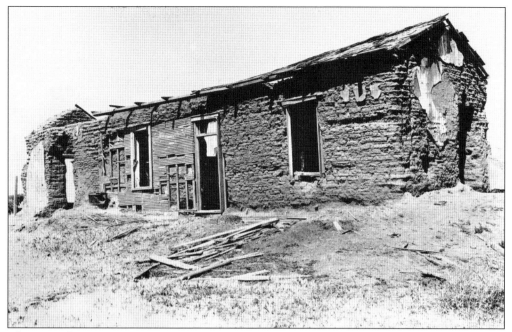

The Argüello Ranch, as La Punta was eventually called, was used by soldiers as a lookout in World War II. It was occupied until the early 1950s, and then it was abandoned. Over the years, the adobe began to melt. When Interstate 5 was built, the old landmark was wiped out for an interchange at Main Street north of Palm City. (CVPL.)

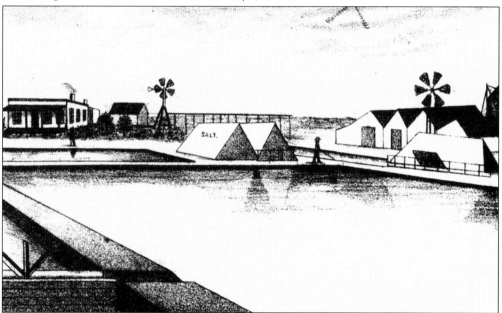

Josiah Shaffer and George Stone founded a commercial salt plant in February 1870 and called it La Punta Salt Works. Three hundred tons were produced from San Diego Bay that year. They expanded the salt works to meet increasing demands. By 1883, they were the only operating salt plant in the county, and annual production was large enough to supply all of Southern California. (RCM.)

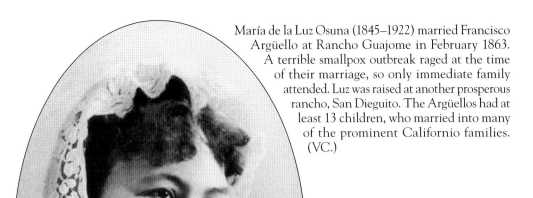

María de la Luz Osuna (1845–1922) married Francisco Argüello at Rancho Guajome in February 1863. A terrible smallpox outbreak raged at the time of their marriage, so only immediate family attended. Luz was raised at another prosperous rancho, San Dieguito. The Argüellos had at least 13 children, who married into many of the prominent Californio families. (VC.)

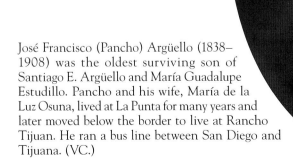

José Francisco (Pancho) Argüello (1838–1908) was the oldest surviving son of Santiago E. Argüello and María Guadalupe Estudillo. Pancho and his wife, María de la Luz Osuna, lived at La Punta for many years and later moved below the border to live at Rancho Tijuan. He ran a bus line between San Diego and Tijuana. (VC.)

Oldest child of Santiago E. Argüello, María Antonia Argüello (1835–1909) was born in San Diego. She married Alfred Henry Wilcox in April 1863 at Rancho Guajome in a double wedding with her sister Refugio and W. Blount Couts. The Wilcoxes built a separate wooden home, one and half stories tall, on the La Punta ranch. It was sold in 1881 to Zachary Montgomery. (SM.)

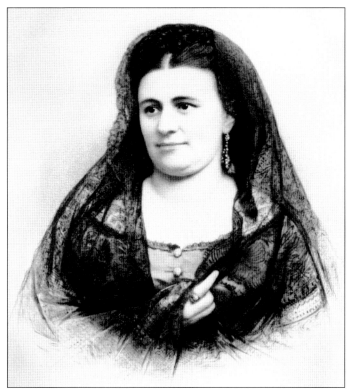

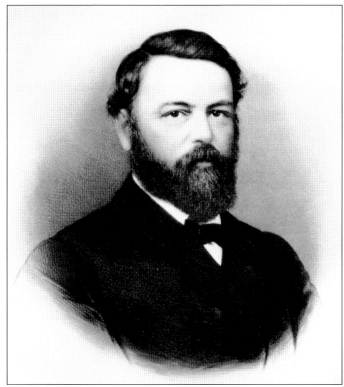

Alfred Henry Wilcox (1823–1883) was a handsome, prominent businessman when he married María Antonia Argüello. Arriving in California in 1849, he made a fortune in steamboat operations at Fort Yuma in partnership with George Alonzo Johnson of Rancho Peñasquitos. He also owned Rancho Santa Ysabel and built a large home in San Diego. He died in San Francisco worth more than $1 million. (SM.)

Tulita. "Capt. Charlie"

Gertrudis Zoila (Tulita) Wilcox (1868–1957) is pictured here in a jaunty pose, taken about 1870. One of three daughters and a son in the Wilcox family, she spent some of her early years at La Punta. The Wilcox children enjoyed sailing in their father's yacht *Ariel* from La Punta to San Diego. Tulita married Randolph Huntington Miner in 1888 and lived in Europe, following her husband's naval duties. (SM.)

María Antonia Argüello de Wilcox, her daughter Francisca (Fannie) Wilcox Drake, and Fannie's two children, James Wilcox Drake and Daphne Drake, are shown in this photograph of three generations taken about 1904. Fannie (1865–1931) was born at La Punta. When grandmother María Antonia died, she willed James Wilcox and Daphne money for their education. (SM.)

Alfred Henry Wilcox Jr. (1872–1939) is shown in this photograph. The usual Victorian fashion was to dress young boys and girls alike. He and his wife, Katherine, moved to Los Angeles and spent 40 years working in real estate. Wilcox was prominent in various Los Angeles civic and fraternal organizations. Upon his death, his estate was valued at $1 million. (SM.)

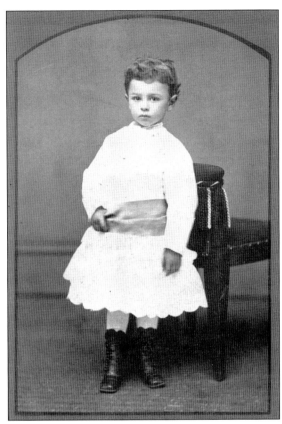

From left to right, Francisca (Fannie) Wilcox, Mabel Bloomington, and María Antonia (Mamie) Wilcox (1864–1950) showed their beauty in this 1883 photograph. The Wilcox daughters were born at La Punta, and both died in Los Angeles many years later. Mamie married C. Tyler Longstreet in 1886 and lived in Paris, Italy, and Los Angeles. (SM.)

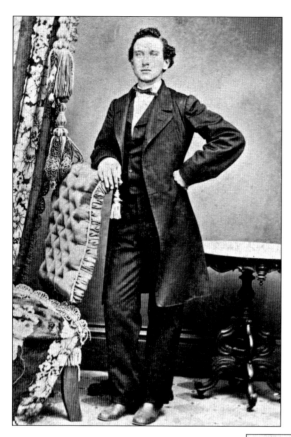

José Juan de la Cruz Argüello (1850–1878) was the youngest child of Santiago E. Argüello and María Guadalupe Estudillo. New Town San Diego founder William Heath Davis and his wife, María de Jesús Estudillo, served as godparents at his baptism. He grew up at Rancho La Punta. This Los Angeles photograph was taken while he was a student at St. Vincent's College. (SM.)

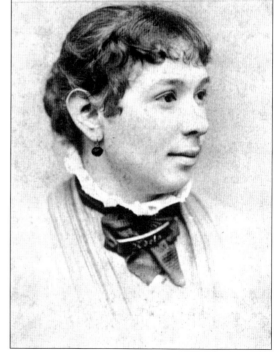

María Adela Argüello (1863–1955) was the oldest daughter of Francisco (Pancho) Argüello and Luz Osuna. She married her first cousin, George Allan Couts, son of Refugio Argüello and W. Blount Couts. Adela was born at Rancho Tijuan. (VC.)

Juan Bandini (1800–1859), prominent San Diego leader and politician, owned ranchos at Tecate and at the ex–Mission Guadalupe in Baja California. He also owned Rancho Jurupa in San Bernardino County. Due to his declining health, Bandini traded ranchos in May 1858 with his father-in-law, Santiago Argüello, to be nearer to his Old Town San Diego home, giving Bandini the Rancho Tijuan and Argüello the Rancho Guadalupe.

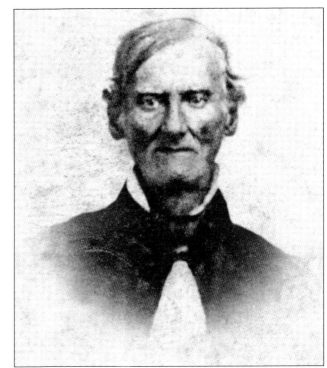

After the death of Santiago Argüello, his widow, Pilar, was faced with keeping Rancho Tijuan intact. Boundaries were unclear, with the ranch crossing the border. Mexican law restricted land grant size. In 1870, Pilar sold half of Tijuan to her son Ygnacio Argüello (1830–1883), pictured here. Eventually, the ranch was divided, with heirs of Ygnacio taking the southern part and the other descendants taking the northern land. (SM.)

ACROSS AMERICA, PEOPLE ARE DISCOVERING SOMETHING WONDERFUL. *THEIR HERITAGE.*

Arcadia Publishing is the leading local history publisher in the United States. With more than 4,000 titles in print and hundreds of new titles released every year, Arcadia has extensive specialized experience chronicling the history of communities and celebrating America's hidden stories, bringing to life the people, places, and events from the past. To discover the history of other communities across the nation, please visit:

www.arcadiapublishing.com

Customized search tools allow you to find regional history books about the town where you grew up, the cities where your friends and family live, the town where your parents met, or even that retirement spot you've been dreaming about.